A TOUR
of
HISTORIC
Sullivan's Island

A Tour of Historic Sullivan's Island

CINDY LEE

The History Press

Published by The History Press
Charleston, SC 29403
www.historypress.net

Copyright © 2010 by Cindy Lee
All rights reserved

Cover design by Natasha Momberger

First published 2010

Manufactured in the United States

ISBN 978.1.59629.865.1

Library of Congress Cataloging-in-Publication Data

Lee, Cindy.
A tour of historic Sullivan's Island / Cindy Lee.
p. cm.
Includes bibliographical references.
ISBN 978-1-59629-865-1
1. Sullivan's Island (S.C. : Island)--Tours. 2. Historic buildings--South Carolina--Sullivan's Island (Island)--Guidebooks. 3. Historic sites--South Carolina--Sullivan's Island (Island)--Guidebooks. 4. Sullivan's Island (S.C. : Island)--History. 5. Sullivan's Island (S.C. : Island)--History, Local. I. Title.
F277.S77L44 2009
975.7'91--dc22
2009052249

Notice: The information in this book is true and complete to the best of our knowledge. It is offered without guarantee on the part of the author or The History Press. The author and The History Press disclaim all liability in connection with the use of this book.

All rights reserved. No part of this book may be reproduced or transmitted in any form whatsoever without prior written permission from the publisher except in the case of brief quotations embodied in critical articles and reviews.

Contents

Acknowledgements 7

A Brief History 9
The Colonial Period * *The Summer Retreat* * *The Modern Era* * *Touring the Island*

Breach Inlet and the Marshall Reservation 23
Pirates * *June 28, 1776* * *The Civil War* * *The* Hunley * *Seaview City* * *William Thomson Memorial Bridge* * *The Underground Houses of the Marshall Reservation* * *Eye of the Storm*

Atlanticville 37
C. Bissell Jenkins House * *Pearlstine House* * *Oleander Cottage* * *Pregnall House* * *Ben Sawyer Bridge* * *Truesdell's Oyster Plantation* * *The Church of the Holy Cross* * *Water Tower* * *2424 Middle Street* * *Bruggeman's Farm* * *Sullivan's Island Graded School* * *The Cemeteries* * *New Brighton/Atlantic Beach Hotel* * *Joseph S. McInerny House*

Contents

Moultrieville ... 55
 *Mortar Battery Capron/Battery Pierce Butler (The Mound) * Bandstand * Battery Thomson * Battery Gadsden * Devereux Mansion Gatehouse * U.S. Coast Guard Station and Sullivan's Island Light * Octagonal House * John B. Patrick House * Henry Siegling House * William Gaillard Mazyck House * Rear Entrance of the Fort Moultrie Military Reservation * Officer's Row * The Sand Dunes Club * Sullivan's Island Baptist Church * Noncommissioned Officers' Quarters * Post Exchange * Administration Building * Provost Marshal's Office/ Dispensary * Sullivan's Island Town Hall/Quartermaster's Warehouse and Office * Noncommissioned Officers' Club and Post Theatre * Post Chapel * Site of the Moultrie House * Stella Maris Catholic Church * 1103 and 1109 Middle Street * Cosgrove House * 1026 Middle Street * Grace Church * Lazaretto * Cove Inlet Bridge (aka the Old Bridge)*

Fort Moultrie ... 83
 *Atlantic Intracoastal Waterway * Bench by the Road * William Moultrie Burial Site * Points of Interest Inside * Osceola * Patapsco Monument * Famous People Who Were Here * Battery Jasper (Site of Battery Beauregard) * The Grillage or Bowman's Jetty * Battery Bee*

Sources ... 107
About the Author ... 111

Acknowledgements

I was lucky to grow up east of the Cooper River. I remember a time when Mount Pleasant was just a small town. When it seemed like everyone knew one another—or was related to one another. It was very much a Mayberry existence. As a teenager, I thought it was boring. Standing on the beach, I'd watch the ships cruise by and wish I was on them going to exotic ports of call. I was jealous then. But not anymore.

Growing up, living in other places and having a family of my own has taught me what's important in life. It's not where you go but the company you keep that matters. A lot of people on Sullivan's Island seem to understand that, too. I've met some really nice folks here while researching for this book. Allow me to introduce them to you.

When I began writing this book, one of the first people I contacted was Red Wood, who pointed me in the right direction. He'd been living here for a long time, but he knew someone who'd been here even longer and had roots planted much deeper in the island sand than he did. That led me to Agatha Thomas, a McGuire/Pazaro descendant and former town clerk. I was thrilled to meet her, since I'd read her chapter in Betty Lee Johnson's *As I Remember It*. Mrs. Thomas was gracious and informative when I sat down with her. It was such a pleasure.

Acknowledgements

A friend of my mother's, Eileen Richardson, put me in touch with people who saved me countless hours of research. From her I found my next valuable resource. As part of the very first town council on the island, E.P. Chiola gave me firsthand information that was invaluable. Eileen's sister-in-law, and a lifelong resident, Elizabeth Richardson easily answered questions that were puzzling me for weeks. And she shared interesting tidbits I wouldn't have gotten anywhere else.

On the professional side, Richard Hatcher of the National Park Service was extremely helpful with information on Fort Moultrie. Kat Kenyon at the Sullivan's Island Town Hall was willing and able to give me any contacts that might help me on my journey. Greg Gress from the Sullivan's Island Water and Sewer Department helped me clear up some confusion about the water tower.

Most importantly, my family has been there every step of the way. My mother, Elaine Ramsey, and sister, Sherrie Cummins, eagerly tracked down a list of names for me. And my niece, Stephanie, brought me a plate of food on Thanksgiving while I was holed up in the house trying to make a deadline. My husband, Brian, and sons, Devon and Brendan, had to put up with me and my computer clicking away at all hours. Thanks, guys. Love you.

A Brief History

Sullivan's Island, with its mementoes of peace, its relics of war, its gradually returning prosperity, upon the very confines of an uncertain ocean, is a condensed epitome of the whole Southern country and its unfathomable future.
—*South Carolina Institute, 1870*

Sullivan's Island, by definition, is a barrier island. As the term suggests, it is a natural barrier between the mainland shoreline and the eroding effects of the ocean. Since its early beginnings when the island was formed (between five and ten thousand years ago), it has provided a buffer against the destructive force of nature. Without Sullivan's and its neighboring islands, storm surges from a hurricane would slam full-force into Mount Pleasant and Awendaw.

To understand how the island was formed, imagine that a camera has been taking time-lapse photography of the state from a satellite for the last several thousand years. What you would see is the sea level rising and falling like the tide. This was caused by the earth warming up and cooling off again over time. High tide came up to the present location of Columbia. We can consider low tide to be where it is now. Creeks that run between the mainland and barrier islands are like the tidal pools of water trapped in the low spots when the tide goes out.

Gradually, vegetation and wildlife filled in the barren landscape of the island. A maritime forest of wax myrtles, water oaks and palmettos provided a canopy for a variety of birds, from raptors to swallows. Barrier islands like this have always been popular with bird-watchers since they provide three very separate and distinct ecosystems for birds to live in—the beach, forest and wetlands. Migratory birds have also used the island for thousands of years as either a stopover to Florida or a winter vacation home. They were, essentially, the island's first tourists. The American oystercatcher, a migratory bird that apparently likes it here enough to stay full time, lives along the Back Bay of the island and is considered a high priority on the United States' Shorebird Conservation Plan.

Following the animals to the island were the indigenous people called See Wee. Barrier islands like Sullivan's provided them with all the fish and oysters they could eat. They also hunted the white-tailed deer and the eastern wild turkey here. Though you won't see them grazing on Sullivan's Island anymore, you can still catch glimpses of deer on neighboring islands. Like the See Wee, red wolves once hunted on these barrier islands until they became nearly extinct in the wild. In 1978, the wolves were successfully reintroduced on Bulls Island as part of the Cape Romain National Wildlife Refuge.

The Colonial Period

By 1500, Spain was planting little settlements in the Americas and looking for gold and anything else that might have been of value to the Crown. Explorers came here but made no permanent settlement. They did, however, leave horses behind in case they came back and needed them. These marsh tackies, as they were later called, were some of the first horses that English planters used for work and racing.

The first English settlers arrived in 1670 at Albemarle Point on the Ashley River. Captain Florence O'Sullivan (sometimes spelled "Sullivant") was among this group, and Sullivan's Island was named

A Brief History

for him. He was from Saint Margaret Parish, Westminster. As an army captain, he'd fought against the French in the West Indies in 1666 and was taken prisoner to France. As his reward for faithful service, he was granted over two thousand acres east of the Cooper River and was appointed the first surveyor general by the Lords Proprietors. He arrived on the ship *Carolina* with his seven servants and wrote that summer to Lord Anthony Ashley Cooper, a Lord Proprietor of Carolina, that the place they chose had exceeded their expectations. There were plenty of hardwood trees from which to build their homes and an abundance of game and fish. He also wrote that the soil grew anything they put in it.

Two years later, the first lookouts were placed in "New Towne" and on the peninsula of Oyster Point that is downtown Charleston today. Guns were placed at those locations as a "publick alarm" in case of enemy approach. In 1674, the Grand Council posted a lookout on the island at the "base of the river" to fire cannon if a ship approached. Captain O'Sullivan, who had been one of the first five deputies of Charles Towne, was selected for the task.

At the time, the British colony of Carolina was the nearest neighbor to the Spanish colony of Florida. Therefore, settlers at Charles Towne and St. Augustine, like England and Spain, were enemies during the Dutch war (1672–78). Each group was concerned that the other might instigate the Indians against them or steal their slaves. Suspicion was reason enough to attack. O'Sullivan was among the fifty volunteers under Lieutenant Colonel John Godfrey who staged an attack in 1672 against the Spanish and Westoe Indians at St. Helena Island, driving them back to St. Augustine.

In 1680, the colonists moved the settlement of Charles Towne to the peninsula at Oyster Point. Some settlers had already been living there since at least 1672. It was considered a healthier and more easily defendable location. About that time, they began to view Sullivan's Island as "a place of prime necessity," and by 1694 a watch house had been constructed on it. Harbor pilots responsible for directing ships around the shallows and sandbars in the harbor were also chosen to live here. It was easy for them to see approaching ships far enough in advance to have time to sail out to them and bring them in safely. O'Sullivan, by this time, had

died and left his property to his orphaned daughter Katherine, who sold it all to John Barksdale.

It has been said that rice first came to Charleston through Sullivan's Island in 1695. A ship from Madagascar was at anchor off the island, and Thomas Smith visited the captain, who shared some rice seed with him. Smith was successful in cultivating that first crop on his property in Charles Towne. He shared it with local planters who, with the expertise of the African slaves, learned how to cultivate it in the Lowcountry marshland and how to clean and prepare it. Carolina rice was in high demand, and several of these men made their fortunes with it, producing at its height one hundred bushels of rice an acre.

By 1701, the island had been emptied of many of its native myrtles, oaks and palmettos to "make it remarkable to mariners." Only a few large trees were left standing as points of reference for the harbor pilots. The flattened topography provided a clear view for a lookout to prevent surprise attack, which came in 1706 in the form of a small fleet of Spanish and French ships.

It was the War of Spanish Succession, ignited by the death of the childless king of Spain in 1700. A major contender to replace him on the throne was the grandson of the king of France. England, among other countries, was not about to let the balance of power in Europe tip in favor of the French. So for the next thirteen years, war raged in Europe and spilled over into the colonies. Charles Town, as a result, was vulnerable to attack.

On Saturday, August 24, 1706, Captain Stool arrived in Charles Town from St. Augustine, where he had been engaged in battle with a French ship. As he retreated north, that ship apparently followed him and brought some friends. No sooner had Stool arrived than the signal was sent on Sullivan's Island—"four or five smokes…which signified that so many vessels were seen." The French and Spanish ships were crossing the bar and making soundings to check the depths of the harbor and prevent running aground. That gave the people at Charles Town time to react. Colonel William Rhett gathered a militia together and ordered merchant vessels to be fitted out for battle. Together with reinforcements from the Santee plantations, they watched nervously as the ships anchored off the island.

A Brief History

On Wednesday, a French messenger approached Charles Town under a flag of truce. He informed the colonists that they had one hour to surrender the town to the king of France and submit to being prisoners of war. The royal governor replied that he "needed not a quarter of an hour or a minute's time to give an answer" and vowed to defend the town for the queen of England. The next day, the enemy split up and landed on James Island and above Charles Town from the Wando River. They burned and pillaged as they went and, after being driven off James Island by the Indians, arrived on the Charles Town neck by Friday morning. There they were driven off by a combined force of English and Indians, killing several of the enemy and taking sixty prisoners.

On the following Saturday, Colonel Rhett, now a vice-admiral with a fleet of seven vessels, set out after the French and Spanish and chased them out of the harbor and over the bar. For the next three days, Rhett and Colonel Fenwick pursued the stragglers. More than two hundred French and Spanish soldiers and sailors were taken prisoner. Many years later, references were made to an "old Spanish fort" behind Sullivan's Island along the narrows. Whether this was evidence from 1706 or from the early Spanish explorers, there is no way of knowing.

At the same time Charles Town was fending off the French and Spanish, another enemy was invading—disease. In 1707, an act was passed to build a lazaretto on Sullivan's Island, which was now officially part of Christ Church Parish. Keep in mind that there were no vaccines back then. The only way to prevent the spread of deadly infectious diseases was to quarantine the sick. In the early 1700s, some of the most prevalent viruses were spread through close contact, such as on a ship. Smallpox was among the most deadly. Victims who managed to survive it carried scars left by the lesions. Epidemics of smallpox were reported all over the colonies. Typhus was also brought in on ships. Also known as "ship fever," typhus was not a virus but rather bacteria carried by lice, though no one knew that at the time. Symptoms included a rash, severe muscle aches, a high fever and delirium. Victims often fell into a coma before dying.

All passengers and sailors from diseased ships were forced to wait on the island for several days until a doctor cleared them for

A TOUR OF HISTORIC SULLIVAN'S ISLAND

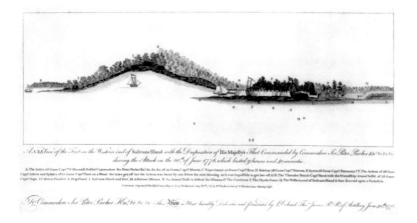

The perspective of the fort from the British ships as they attacked on June 28, 1776. *Courtesy of the Library of Congress.*

entry into Charles Town. It may seem cruel, but the alternative was to stay on the ship for the same number of days. After eight to ten weeks crossing the Atlantic Ocean, passengers were eager for terra firma, even if it was in quarantine. Beginning in 1744, all slaves arriving on ships were required to be quarantined at the lazaretto for ten days. Captain Caleb Godfrey complained in 1756 that the slaves he brought to the island were "in poor order" after their ten-week voyage and that the poor market, coupled with the mortality rate, would cause him to lose money.

Being a quarantine station was the main purpose of the island until the Revolutionary War thrust it into the limelight. For two years, America was drawing closer to independence. In September 1775, South Carolina evicted its royal governor, William Campbell, who sailed from Sullivan's Island with the British garrison that had been housed in the lazaretto. Now he was coming back with an army and a fleet of ships to take back control of the colony. Under the direction of Colonel William Moultrie, construction began on a small fort of palmetto logs and sand in January 1776. At the other end of the island near Breach Inlet, Colonel William Thomson was charged with building an earthwork as well. The British were confident of success and bragged that on June 28 they

would "breakfast at Sullivan's Island, dine at Fort Johnson, and sup in Charleston." It would be four years, however, before they would get a chance to enjoy a meal here. The British were defeated and were unable to take Charleston until 1780.

The Summer Retreat

When the war ended in 1783, the island became a quarantine station once again. Goods from disease-ridden areas were now required to be quarantined on Sullivan's Island for over a month. The following year, John Calvert designed and built a new lazaretto and warehouse constructed of local pine and lime from oyster shells. Captain Simon Tufts, a Revolutionary War veteran, was placed in charge of all public buildings on the island, which included these two buildings and the fort.

If Tufts thought that he would have the run of the island all to himself, he soon found out that he was wrong. Life was changing now that peace had arrived, and people were beginning to see Sullivan's Island as a summer resort and a healthful retreat. In 1791, the state legislature passed a resolution allowing people to build on half-acre lots under the condition that the state could evict them from Sullivan's Island at any time in case of war. Now that the floodgates were officially opened, people began pouring in, and Tufts soon complained that they were putting their houses too close to the public buildings.

Progress couldn't be stopped, however. In 1792, James Hibben advertised in the *City Gazette* and *Daily Advertiser* that he and Captain Main had "a sufficient number of boats" and would take "carriages, horses, cattle, etc. during the summer and fall to and from Sullivan's Island." In 1813, John D. Delacy completed a line of steamboats that carried passengers to destinations between Richmond, Virginia, and Savannah, Georgia. He also owned the steamer *Paul Hamilton*, which brought people to the island from Charleston during the summer.

The first to build houses here were the wealthy and influential families of Charleston and the surrounding plantations. They included the Middletons, Draytons, Izards, Elliotts and Pickneys. A former member of Congress, Ralph Izard, died here in 1813. Charlestonians came first to escape the summer epidemics in the city. An 1817 letter from a Charleston resident to a friend, published in the *Newburyport Herald*, complained of a particularly wet summer and described the yellow fever epidemic. "This city presents one scene of desolation," he wrote. "Business of all kinds is almost completely stagnant. A great proportion of the whites have left the city—strangers for the northward and the natives for Sullivan's Island." Coming to the island did not always inure people against contracting yellow fever. Cases (even epidemics) occurred occasionally. The worst were in the summers of 1817, 1827 and 1852.

People also began coming for amusement. One of the first hotels on the island was operated by Jehu Jones, a free African American and prominent hotelier in the city. A portly, well-dressed man, Jones was best known for his honesty and enterprise. He owned a tailoring business on Broad Street as early as 1805 and two hotels, one next to St. Michael's Church in Charleston and one at the southern end of Sullivan's Island. An advertisement he placed in the summer of 1817 announced that he'd recently purchased a carriage and gentle horses to take his visitors on a tour of the island. He also stated that he "spared no expense to make the Establishment as comfortable as possible, and to make the charges as low as the very high expense of the Establishment will admit." The weekly rate was fourteen dollars per person. Children were half price, and ice cream was served every day (an impressive feat before refrigeration!).

Jones sold a parcel near the point with "a small but pleasant house" in 1819, apparently to run a bigger establishment. In 1823, this "genteel resort" with several buildings on one of the best lots on the island went up for sale. The main house had sixteen rooms. Another had seven. There were also outbuildings that included a two-story kitchen house and a stable/carriage house. The profits that he acquired from his businesses were sometimes used to purchase the freedom of local slaves.

A Brief History

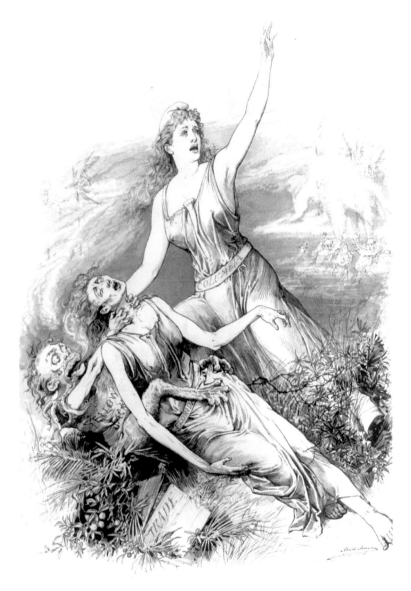

Yellow fever claims a life as it arrives in infected cargo. The United States looks on, helpless. *Courtesy of the Library of Congress.*

A variety of boardinghouses were also erected. Among them were McIntire's, Muggridge's and Wilkie's. To further accommodate visitors, a tavern was set up at the landing in the 1790s, and the managers of the Charleston Theatre built the South Carolina Lyceum, "a spacious and well ventilated saloon… for utility, amusement and instruction." It was open for one month in the summer. In the 1840s, steamers ran pleasure cruises to the bar. There were also three churches open during the summer as early as 1847: Grace Episcopal Church, St. John the Baptist Catholic Church and a Presbyterian church.

The summer population at that time was said to be as much as one thousand people and two hundred houses. On Sundays, day-trippers came to picnic and enjoy the beaches. William Gilmore Simms wrote,

> *Hither may they come in midsummer, and remain till frost, in perfect security, and realizing that luxury—that of salting themselves… They may come and refresh themselves upon shrimps, fish and oysters, bathe in Neptune's own bath, and enjoy a thousand sports at once novel and attractive…At our feet lies a proof of powers in the great ocean, the display of which, to the man accustomed only to the forest and the mountain would be such a spectacle as his thought would brood upon for long seasons after.*

Of course, the most memorable "proof of powers" were the hurricanes that periodically ravaged the island. The first major hurricane reported in the area occurred on September 15, 1752. All of the vessels in the harbor were thrown onto the shore, and the first lazaretto was carried off to Hobcaw (in Mount Pleasant) with fifteen people in it, six of whom miraculously survived by hanging onto the rafters. In 1822, the daughter of Gabriel Manigault (Mrs. Lewis Morris) was killed along with her son, his tutor and a slave when the house they were in collapsed during a hurricane. Fifteen houses were destroyed in that storm. Another devastating hurricane ripped through in 1911, causing significant damage. And during the earthquake of 1886, the island was said to have been submerged under a tidal wave.

A Brief History

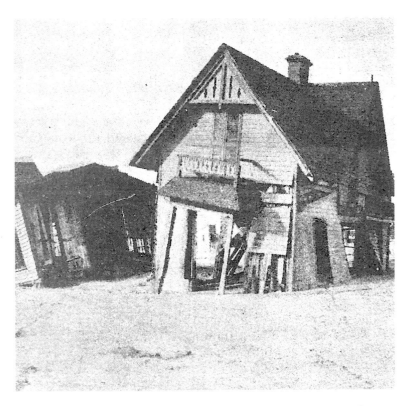

This photo appeared in *Harper's* magazine showing hurricane damage on the island in 1911.

Still, in spite of the hurricanes, people continued to come to the island. In 1817, the town of Moultrieville was incorporated, commissioners were elected and police were appointed to keep the peace. Among the first commissioners were Jacob Bond I'on and Charles Cotesworth Pinckney Jr. Streets were laid out, and with the growing population, a new election district, Berkeley County, was formed out of Charleston County in 1882. It included Christ Church Parish and, with it, Sullivan's Island.

Beginning in the 1840s, European immigrants moved to the island. The McGuire family is one example. They chose to settle among the myrtles and sand hills of a barrier island instead of living in a city like many immigrants did. It's easy for us now to see why

they would have wanted to live here, but don't forget that at the time the only way on and off of the island was by boat. It was not a place to get rich, by any means, but certainly a place to get away from it all and raise a family. John McGuire opened a store across from the fort at Station 13 and made a modest living. Other immigrants soon followed, and by the turn of the century, the island was a melting pot of Irish, Italians, Scottish, Germans and Danes.

From the outbreak of the Civil War in 1861 until its conclusion four years later, almost no civilians were left on the island as the Confederate artillery took over to defend Charleston Harbor. Because no one owned the land but only leased the right to build on it, they had little cause to stay. Beach houses were commandeered by soldiers or destroyed by artillery shell.

The Modern Era

Not long after the war was over, the residents and tourists came back. In 1874, the Mount Pleasant and Sullivan's Island Ferry Company built a wharf and ferry house on the cove side. Their ferries made three trips a day and two on Sunday, bringing passengers from Charleston round trip for a fare of twenty-five cents a head. An estimated 200,000 passengers were brought to the island annually. In 1887, Poor's Directory of Railway Officials listed the Middle Street and Sullivan's Island Railroad Co., which operated along two and a quarter miles of road with fifteen horses and seven cars.

Soon the population would grow even more. In 1898, the secretary of war, in preparation for the possibility of a conflict with Spain, created the Department of the Gulf. Six states from Texas to South Carolina were placed under the leadership of Brigadier General William M. Graham, headquartered in Atlanta. The War Department then purchased property from surrounding island residents in its efforts to expand the fort. By 1908, new batteries dotted the island, and a growing number of military families were

A Brief History

calling the island home. The increased military presence sparked an economic turnaround in post-Reconstruction Charleston.

At the same time, the Charleston–Isle of Palms Traction Company was in operation. Its railway line ran across the cove from Mount Pleasant through Sullivan's Island to the Isle of Palms. The company also supplied light and power to both islands. The number of permanent residents was now beginning to match the number of seasonal ones, until eventually their needs were too big to ignore. In the 1920s, a long-awaited school was built. By 1926, as cars began to take over the roads, the trolleys were retired and the Cove Inlet Bridge was converted for automobile traffic.

World War II brought more construction to the island, which by now extended all the way to Breach Inlet. After the close of the war, the federal government decommissioned Fort Moultrie and sold much of its property to the town and residents. The Ben Sawyer Bridge was built, and streets were added beyond Station 23. Because street names were changed between 1940 and 1968, the old names are included throughout the book. Out of fear that being a township left the island vulnerable to annexation by larger municipalities (such as Charleston), island residents petitioned the state to allow them to vote on becoming a town. It passed in 1975, and the town of Sullivan's Island was established.

Touring the Island

There aren't enough pages in one book to cover all of the interesting houses on the island. My primary focus has been on the public buildings and military installations, the obvious structures we've all wondered about. As for the others, here are some clues to look for when trying to determine how old a beach house might be.

The most obvious feature to look for is the elevation. Sullivan's Island is in a flood zone, and there are building codes today that require new houses to be elevated above the base flood elevation (BFE). BFE is simply how high floodwaters may get in a certain

area during a worst-case scenario like a major hurricane. So a house built right on the beach after 1970 is typically raised high enough to park a car under it. Even if the codes don't require the house to be a full nine feet off the ground, the general opinion has been that since you have to spend the money on a basement, you might as well make it useful. The exceptions to the rule are the older homes that were raised after Hurricane Hugo. Houses built before 1950 were built on foundations with crawl spaces to keep them off the damp ground and prevent rot. In the 1950s and 1960s, however, brick ranch houses on cement slabs were popular.

Barrier islands expand and contract as currents either add or take away sediments such as sand and shells. Sullivan's Island is no different. In fact, it is wider today than it was just one hundred years ago, and it will look different one hundred years from now. Man can only slow down or speed up the progress but not stop it. Houses in Atlanticville and parts of Moultrieville that are on the beach are generally newer than many of the houses on Middle Street and Jasper Boulevard.

Finally, what may surprise you is the number of structures listed on the National Register of Historic Places. As you drive around to admire these historic structures, however, please be mindful that some of them are private residences. This is still a living, breathing community. History is happening here still.

Breach Inlet and the Marshall Reservation

Here may the idler behold the porpoise, in vast schools, rolling and plunging with an obvious joy and luxury. Here, safe himself, might he behold the storm-spirit rioting in his native element, and the great ship, cowering and stifled in his wild embrace, lifted up, as an infant in the grasp of a giant, and flung scornfully upon the shores, as if to mock the builder and the owner, with the folly and feebleness of his creation.
—William Gilmore Simms, 1849

We begin our tour on the eastern end of the island, where the inlet separates Sullivan's from the Isle of Palms and the "waves have cut for themselves an avenue." At first glance, it looks like any other inlet, but there is much more history here than meets the eye. In fact, some of the events that put Sullivan's Island in the history books happened right here at this spot.

Look toward the marsh and you'll notice that Breach Inlet splits off into two different directions. The creek you see leading off to the left is called Conch Creek. It meets with the Sullivan's Island Narrows, and together they form a natural canal that winds through the marsh from Charleston Harbor to this location. For over one hundred years, it was the easiest and safest way for small craft to get to this spot, avoiding the rough waters of the harbor.

Before the creation of the Intracoastal Waterway, small boats and canoes would wind their way up the Carolina coast using rivers and creeks like the Narrows. Paddling through took some time, and it was easy to get lost in the serpentine creeks, so an occasional path was dug out to create a shortcut.

Pirates

The uninhabited north end of the island was a good place to hide in the eighteenth century, which brings us to our first subject—pirates. The most notorious pirate to walk the island was Stede Bonnet, captured here on November 6, 1718, a day after his crew was sentenced to death by hanging in Charles Town.

Bonnet was twenty-nine years old when he abandoned his plantation on the Caribbean island of Barbados and set off on a career of plundering on the high seas. Meanwhile, his wife, Mary, was left at home to fend off his creditors, raise four children and face the rumor mill that blamed his sudden departure on her nagging.

In his newly outfitted ship, *Revenge*, Bonnet quickly built a reputation by allying himself with the infamous Blackbeard (aka Edward Teach). Together they terrorized Charles Town in 1718, taking prisoners from a merchant ship and holding them hostage. At least thirteen vessels were taken by Bonnet during his short career.

It has been said that pirates were once tolerated, even welcomed, in Charles Town. But the truth is that only privateers were made welcome here. They were contracted by the British government to seize the cargos of enemy ships (namely the Spanish and French). Privateers brought the spoils to the Court of Admiralty in town, which gave them their share and kept the rest for the king. Charles Town benefitted when the privateers spent their money with local merchants. Bonnet at one point claimed that he was acting as a privateer but had no such permission. To elude capture, he changed his own name twice and that of his ship to *Royal James*. It didn't

Breach Inlet and the Marshall Reservation

work, however. He and his crew were apprehended and brought into Charles Town on October 3, 1718.

While the crew was placed in the watch house (now the Exchange Building in Charleston), Bonnet and his Jamaican sailing master, David Harriot, enjoyed the privileges of gentlemen and were kept at the home of Mr. Partridge, the marshal of the town. Bonnet had a number of sympathizers in Charles Town who didn't want to see one of their own rank hanged for piracy. It was only a matter of time before he would escape.

No one knows how, but Bonnet and Harriot simply walked out of the marshal's house on October 24. For nearly two weeks they remained hidden as the rest of the crew was brought to trial. Rumor had it that Bonnet was trying to make contact with a pirate named Moody sitting just outside the harbor. Finally, on November 6, Colonel William Rhett and his men discovered Bonnet and Harriot here on the north end of Sullivan's Island. Shots were fired during the arrest, and Harriot was killed. Of Bonnet's thirty-three crew members, only a few were acquitted. Most were hanged on November 8 at the tip of the Charleston peninsula, facing the harbor, so that all those who may consider that line of work could witness the consequence.

Two days later, Bonnet was brought to trial for "feloniously and piratically" taking the sloops *Francis*, *Fortune* and eleven others. Bonnet pled not guilty on both counts. "Though I must confess myself a sinner," he declared, "and the greatest of sinners, yet I am not guilty of what I am charged with." According to Bonnet, he had been headed from North Carolina to St. Thomas for a commission as a privateer against the Spanish. On the way, he claimed, the quartermaster and others onboard had decided to take the British vessels against his will. When witnesses contradicted his story, he changed his plea on the second count to guilty. Judge Nicholas Trott of the Court of Vice Admiralty pronounced the sentence of death. Bonnet wrote an impassioned plea to Governor Johnson asking for pardon. "I heartily beseech you'll permit me to live," he wrote, "and I'll voluntarily put it ever out of my Power (to plunder again) by separating all my Limbs from my Body." On December 10, Bonnet, like his crew, was hanged among the sun-bleached mounds of oyster

shells at White Point and buried there in the pluff mud below the high-water mark.

Meanwhile, Richard Worley, a pirate from New York, was heavily armed and perched just outside the mouth of the harbor with two merchant vessels he'd recently captured. Charles Town's troubles would not be over for some time yet. In 1745, a Spanish privateer attacked the ship of Thomas Poole, a branch pilot for the bar stationed on the island.

June 28, 1776

In the eighteenth century, the water here was simply known as "the Breach." It was said that at low tide it was too shallow to take a boat across it. At high tide, however, it was estimated at around seven or eight feet deep. That was the guess that General Sir Henry Clinton made on June 28, 1776, when his regiment was poised to attack the American rebels from Long Island (as Isle of Palms was then known) across the way.

He was criticized for not crossing the inlet to attack the forts by land. Americans later made fun of him for being afraid to wade in waist-high water. The fact is that this small stretch of water is extremely dangerous. Swimming along this part of the beach is against the law today. Its deadly currents have claimed the lives of many unsuspecting swimmers. Nevertheless, if Clinton and his men had been successful in getting across, they may not have survived the onslaught waiting for them on the other side.

By February 1776, under the direction of Colonel William Thomson, construction had begun on an advanced post to protect the eastern end of the island. Three months before, he'd been in the backcountry with fifteen hundred rangers fighting the Loyalists. He brought Loyalist prisoners back with him to Charles Town and put twenty of them to work building his battery on Sullivan's Island. All the while, the British ships *Tamar* and *Cherokee*, having abandoned the island to find provisions, were lying in wait at the mouth of

the harbor. As construction here and at the other end of the island continued, the *Syren* and the *Raven* appeared. Tensions mounted, and letters were sent out across the colony in search of men with rifles to help defend the island.

General Clinton was well on his way, sailing with Sir Peter Parker from Cape Fear, North Carolina, as Thomson was still drumming up volunteers. In June, Clinton landed on Long Island with three thousand well-trained, well-equipped British Regulars to quell the "most unprovoked and wicked rebellion." Shots were exchanged periodically beginning on June 21. On June 28, Colonel Thomson's regiment of over seven hundred rangers and Colonel Muhlenburg's two hundred militiamen from North Carolina and Virginia fired at the British and kept them from attempting to cross the inlet. Ten days later, Clinton abandoned Long Island.

The Civil War

In the early morning hours of April 12, 1861, Colonel J. Johnston Pettigrew and his rifle regiment were spectators on the beach the moment the first shot of the Civil War was fired from Morris Island. Having been stationed there just recently and knowing that he would not be directly involved in such a historic moment must have been frustrating for a man who would later turn down a promotion so he could stay in the action.

But Sullivan's Island would soon play an important part in the war, too. The same battery that once prevented the British from crossing the Breach was in use once again, its guns trained against the South Atlantic Blockading Squadron. When correspondence was exchanged between the Union and the Confederates, a flag-of-truce boat was sent from here to meet the enemy's flag-of-truce boat one mile directly out in the harbor.

The view of the Isle of Palms from here was especially desolate during the Civil War. The Confederate army flattened all trees and

tall bushes for two miles on that island to prevent an enemy ambush and provide a more panoramic view for coastal defense. Former slave Jacob Stroyer wrote after the war,

> *The way the Confederates came to the knowledge that Union soldiers were on Long Island was that…one night quite a number of* [slaves] *escaped by swimming across the inlet…and succeeded in reaching the Union line. The next day it was discovered that they had swam across the inlet, and the following night they were pursued by a number of Confederate scouts who crossed in a flat boat. Instead of the capture of the negroes…the Confederate scouts were met by soldiers from the Union line, and after a hot engagement they were repulsed.*

The *Hunley*

This is also the location of departure for the Confederate submarine *Hunley* the night it sank the *Housatonic* on February 17, 1864. The sub came from Mobile, Alabama, where it was built of iron plates riveted to a forty-foot-long circular skeleton. To propel it, eight crew men cranked furiously by hand while the pilot operated the wheel and levers to maneuver the craft. It was a mere three and a half feet wide on the inside. With the heavy breathing that comes with exertion, the hull quickly grew stale with carbon dioxide and the smell of sweat. The air-exchange mechanism was of little help. Rigged to the front of the boat was a twenty-two-foot pine boom, the other end of which held a copper cylinder filled with ninety pounds of explosives.

Oddly enough, they had no trouble finding volunteers to operate the *Hunley*. To the crew men, the reward far outweighed the risk. John Fraser & Co. offered $50,000 for every U.S. monitor sunk plus a settlement to the families of those who died in the endeavor. In August 1863, all but three of the crew drowned when the submarine was swamped by the wake of a passing ship. Before the next attempt,

Breach Inlet and the Marshall Reservation

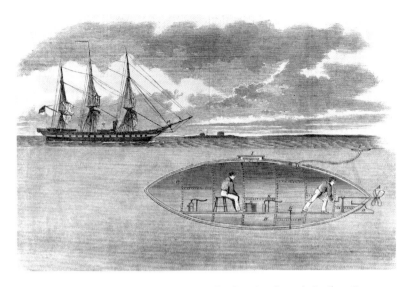

An early design of a submarine showing a floating air tube to help the sailors breathe. *Courtesy of the Library of Congress.*

Lieutenant Payne, who had been in command and managed to escape, happily transferred back to Mobile.

One of the builders of the submarine, Captain Horace L. Hunley, was confident that he could do better and volunteered to take command. He and a new crew fresh from Mobile took the sub into the harbor to practice diving and resurfacing. It was while they were performing one of these exercises on October 15, 1863, that they forgot to close the ballast tank. The bow drove deep into the mud. The sub failed to resurface, killing all onboard. Captain Hunley's body was found with his head and hand (still holding a candle) in the hatchway. Each time the *Hunley* sank, they raised it out of the water, buried the dead and tried again.

By this time, General Beauregard was having doubts about the submarine, now nicknamed the "iron coffin," and was reluctant to send it out again. In December, he was persuaded by George E. Dixon, a mechanical engineer from Alabama, to let him take command. Dixon helped design and test the *Hunley* in Mobile. Now at Sullivan's Island, he wrote that he was constantly in the range of Union shells, both day and night.

On the evening of February 17, 1864, he set out from Breach Inlet with a new crew. Under cover of darkness, they slowly made their way past Drunken Dick Shoals toward their target. The sloop-of-war *Housatonic* lay at anchor four miles off the coast. Moments after the officer on the deck noticed "something like a plank" on the water, an explosion ripped a hole in the ship. Of the 150 men aboard the *Housatonic*, only 5 lost their lives. As for the *Hunley*, its signal light was seen moving away from the wreckage and then disappeared.

This time, the *Hunley* sank and remained at the bottom of the harbor for over 130 years. On August 8, 2000, it was finally raised from the seafloor and is now on display at the Hunley Museum. In 2004, the crew received a proper burial at Magnolia Cemetery next to the previous crew members of the submarine. Included in the procession were nine women dressed as Civil War widows to represent the families of the crew men.

Seaview City

Ever heard of Seaview City? You're in it. On December 20, 1881, an act was passed to incorporate the town of Seaview City on Sullivan's Island. The border ran from Breach Inlet to Station 24 (known as Boundary Street at the time). In 1885, the State of South Carolina promised to sell Seaview City to the tune of $25,000 to the Mount Pleasant and Seaview City Railway Company. The act to incorporate the company stated that the shareholders would be allowed to build and operate a railroad from Mount Pleasant to Breach Inlet only if the Charleston and Sullivan's Island Railroad Company didn't hurry up and finish its railroad by December 23 of that year. The company would have four years to complete construction. If it failed to do so by May 1889, the land went back to the Town of Seaview. The act was repealed five years later.

The Mount Pleasant and Seaview City Railway Company also had plans to build and operate a road to Remley's Point and a

drawbridge from Hog Island across the Cooper River to Charleston. That was a pretty ambitious project at the time—a bridge was not completed there until 1929.

WILLIAM THOMSON MEMORIAL BRIDGE

The bridge across the inlet is William Thomson Memorial Bridge. In 1898, the Charleston Consolidated Railway, Gas and Electric Company built a trolley trestle to carry passengers across the inlet to the new attractions on the Isle of Palms, where visitors could dance at the Pavilion and ride a Ferris wheel. The Charleston–Isle of Palms Traction Company bought the Seashore Division and operated here until 1925.

This bridge is relatively new and is named for Colonel William Thomson of Revolutionary War fame. On any given day, you can find people fishing from the bridge. Flounder, crab, croakers and sharks are prevalent here, and dolphins are frequently spotted from the bridge in the mornings.

The northeastern section of the island was largely uninhabited before 1920. It was all farms and sand hills. The *Southern Patriot* reported in 1848 that "notwithstanding its sandy nature, cultivation and manure has redeemed several gardens from an unproductive to a fruitful state…Figs and plums also flourish here; watermelons, muskmelons, cucumbers, squashes, and succulent vegetables find it a congenial soil."

During the Great Depression, over one hundred acres of high ground from the marsh to Jasper Boulevard between Station 30 and Breach Inlet was claimed by Robert Magwood (1876–1966). The Magwood family has been providing seafood to the Lowcountry for generations. Robert grew up on Bulls Island, where the family had an oyster factory. They brought their oysters on flatboats to Breach Inlet and from here took them to Mount Pleasant. Magwood also rented fishing boats.

A Tour of Historic Sullivan's Island

From Breach Inlet, bear left onto Middle Street. Take the second left onto Station 31. Then turn right onto Brownell. Although the addresses of the next stop are on I'on Avenue, the better view is here on this street.

The Underground Houses of the Marshall Reservation
(3029, 3017 and 3017 I'on Avenue)

On your right you'll find some of the most unusual dwellings in the country. These homes were created out of a military battery built as part of the coastal defense system of the United States. Battery Marshall began as a breastwork during the Revolutionary War. Colonel Thomson and Colonel Muhlenberg were in command of nearly one thousand men who kept a regiment of British Regulars from crossing Breach Inlet. The small fort was described by British commodore Peter Parker as "rebel tents and huts and fort with pieces of guns." On June 28, 1776, these guns, an eighteen-pounder and six-pound field piece, fired on General Clinton's forces on the Isle of Palms.

During the Civil War, Sullivan's Island was heavily defended by no fewer than ten Confederate batteries and fortifications, with this Beach Inlet battery strengthened and enlarged in 1862. It was now a sand work with a bombproof magazine. Stationed here at the time were three companies of the First South Carolina Infantry. With them were slaves borrowed from various plantations to provide labor at the fort. The firepower used here during the Civil War was eight times that of the Revolution and included four guns firing twenty-four-pound balls and a thirty-two-pounder rifled cannon, which provided protection for blockade runners. The battery here was also used as a place of communication under flags of truce between the Union's South Atlantic Blockading Squadron and the Confederate army. Among the correspondence exchanged were letters between prisoners of war and their loved ones.

Breach Inlet and the Marshall Reservation

The Confederate battery at the present-day Marshall Reservation as it looked in 1865. *Courtesy of the Library of Congress.*

At the turn of the twentieth century, all branches of the military underwent a tremendous building program. The army defenses on Sullivan's Island were no different. It was at that time that this area became known as the Marshall Reservation, yet it was left out of the construction project at the time. All that was here were a control tower and a searchlight platform.

It was not until World War II that the Army Corps of Engineers got to work on building a battery here. At 430 feet long and 50 feet high, it was the largest fortification built since Fort Moultrie itself was expanded. The foundation was poured around 45-foot concrete pilings driven deep into the ground. The concrete floor and ceiling are each said to be between 12 and 15 feet thick. Exterior walls are 10 feet thick. Interior walls are up to 4 feet thick.

Guns were mounted at each end of the battery and were only fired twice. Improvements made to the firing power and accuracy of battleship guns made batteries like this one obsolete by the end of World War II.

After the decommissioning of the Marshall Reservation in 1947, the property was subdivided into three lots of over one and a half acres each and sold off. In 1951, the first man to buy one of the parcels and convert it to a house was William R. Wilhauer, a veteran of the Army National Guard who was stationed at Fort Moultrie during World War I. Many islanders at the time thought that Wilhauer was crazy and wondered why anyone would want to live in one of these things. But it didn't take long before the other two were sold.

The owner of the middle section found that the place was damp and much darker than the other sections. His plan was to use it for mushroom farming. When the enterprise didn't take off, he sold it to the Curd family, who felt that, at 250 feet long, it was plenty big enough for their six children. With help from neighbors like the

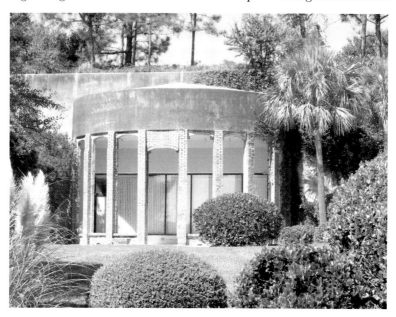

One of the underground houses of the Marshall Reservation as it looks today. *Author's photo.*

Breach Inlet and the Marshall Reservation

Richardson family on Jasper Boulevard, they dug away the earth and sand that covered the wall facing the ocean and blasted a 20-foot hole in it for a door and windows. They also added more light, plumbing and heat to make it livable. Fire escape stairs from the old Roper Hospital in Charleston were salvaged for a staircase to their rooftop terrace. Unlike the other bunker houses, the Curds' house came with a mess kitchen. The dimensions, however, were unusual—46 feet long and 7 feet wide.

The benefits that these houses provide for their owners come from the thickness of the walls. They are very well insulated. Like in a mountain cave, the temperature changes very little from summer to winter. They are also soundproof. When the Curds hired a contractor to bulldoze several feet of sand from the top of their house for a basketball court, they had no idea that he was up there performing the work while they were inside.

Continue on Brownell and turn left onto Station 29. Continue until you reach the end of the road. Turn right onto Marshall Boulevard. There is a house on the beach at the next intersection that will easily grab your attention.

Eye of the Storm

Although this house is not exactly historic, it does reflect an event in our local history that many still talk about today. On September 21, 1989, a category five hurricane named Hugo devastated the Lowcountry. Those who were here when it hit will never forget that overwhelming force of nature and the damage left in its wake. It arrived at high tide, with maximum sustained winds of up to 140 miles per hour and a twenty-foot storm surge (the highest ever recorded on the East Coast). The islands were covered with water, which actually lifted some houses off their foundations and carried them down the street. Among the homes destroyed was one at this address owned by the Paul family.

A Tour of Historic Sullivan's Island

The following year, they replaced it with this monolithic dome, which they called the "Eye of the Storm." This space age–looking residence is an oval stretching eighty feet long and fifty-seven feet wide. It was created using an airform that is inflated by fans and then sprayed on the inside with three inches of polyurethane foam. The structure is then reinforced with steel rebar and sprayed with a layer of concrete.

Just to the left of the house on the beach were four panama mounted guns during World War II. Panama mounts were concrete circular platforms that allowed the gun to be moved from side to side.

Station 28½ was originally called Sixth Street. Turn right onto this street and then make a left onto Atlantic Avenue. Follow this street for two long blocks, just past Station 27, to 2673 Atlantic Avenue.

Atlanticville

It is a mistake to speak of the Island as verdureless. There are farms and gardens above, which show equally the taste and skill of the cultivator, and the susceptibilities of the soil. Clumps of cedar, of oak, and of laurel, gay shrubs and fragrant myrtles, rise up among the sand hills, giving you the oasis amidst the desert.
—William Gilmore Simms, 1849

You are now entering Atlanticville, a section of which is listed on the National Register of Historic Places. Before the Civil War, this area was known as the Myrtles because it was the shadiest part of the island and myrtle trees were prolific here. Visitors in the early 1800s liked to take carriage rides from their hotels in Moultrieville to this quiet and scenic location. It was the preferred place to be on a hot summer day since, as William Gilmore Simms wrote in 1849, Moultrieville had "not a shrub large enough to make a toothpick."

After the Civil War, the business district on Sullivan's Island gradually moved up from Fort Moultrie to this area. Stores and restaurants were built above Station 22 as early as the 1880s. The first five streets from this point on were part of Seaview City at the time. Station 24 was called Boundary Street. Stations 25 through 28 were First through Fifth Streets. It may not seem like it adds up, but

don't forget that there's a Station 26½. In fact, the Simmons family had a store there at the intersection of Middle Street.

Although Atlanticville had a post office from 1903 to 1942, it was never an incorporated town. Still, over time its population grew. Consequently, more streets were added. Goldbug Avenue between Stations 26½ and 28 was added in 1910 and appropriately named New Street. Bayonne Avenue was laid out in 1925.

At the turn of the twentieth century, middle-class families could now afford to stay here. They came and went like the ebb and flow of the tides. The *Sappho* and the *Pocosin* brought visitors regularly from the Market area in Charleston. On weekends, trains brought people from Augusta, Georgia, and Columbia, who then boarded the steamers to the island, all for one fare.

At the same time, more families became part of the year-round culture of the island. They were born here, grew up here, worked here, married here and even died here. This was their home.

C. Bissell Jenkins House
(2673 Atlantic Avenue)

This home was built by Claudius Bissell Jenkins in 1889. He was born in Summerville in 1865 and grew up on Wadmalaw Island. Jenkins moved to Charleston as a young man to work for the machinery dealer Cameron & Barkley. He quickly climbed up the corporate ladder and became president of the company. He was also on the board of directors for the Peoples National Bank at the corner of Broad and East Bay Streets.

Turn right onto Station 26½. Immediately on your left is a sprawling, red-roofed house.

Atlanticville

The front view of the C. Bissell Jenkins house on Atlantic Avenue (circa 1889). *Author's photo.*

PEARLSTINE HOUSE (2629 I'ON AVENUE)

Thomas Pearlstine and his son Isaac immigrated to America from Russia in 1860. Together they made a living selling household items door to door. During the Civil War, Isaac came to Sullivan's Island as a laborer at a saltworks. As early as 1800, salt was produced on the island by evaporating sea water. At high tide, salt water was directed into a pond and then slowly redirected to shallow basins called "salt gardens" or "salines." The salt produced was used to preserve meat and fish before the invention of refrigeration. The salt industry was so vital to survival that tracking down and destroying saltworks was part of the Union strategy of starving the Confederacy into submission.

After the war, Isaac Pearlstine and sons Shep and Hyman went into business for themselves, first with a general store, then a carriage business and eventually a wholesale grocery business (in 1883). This last venture developed into Pearlstine Distributors, one of the largest privately owned companies in the state.

The Pearlstine family owned this house until 1972. The house was built about 1900. The company supplied island store owners like Mary Anne McGuire with grocery stock, often on credit. They knew McGuire would always pay her bills. In fact, she requested on her deathbed in 1938 that her niece Agatha Mueller Thomas pay the last $200 dollars she owed to Pearlstine.

Continue down Station 26½ and stop when you reach the intersection at Middle Street. Across the street to the left you'll see a yellow house.

Oleander Cottage (2630 Middle Street)

This house was built between 1880 and 1902. By all appearances, it is two houses put together in a T shape. At least part of it is said to have been moved here from the South Carolina Inter-State and West Indian Exposition held in Charleston in 1902. The best guess is that it may have been the Louisiana Purchase Building (celebrating the centennial of that event), which had a Dutch roof like the back part of the house.

To see the next few sites, you'll have to make a square. Turn right onto Middle Street and then left onto Station 27. At Jasper Boulevard, turn left. Look for the fourth house on your right with a red tin roof, cedar trees and a yard arm (T-shaped flagpole).

Pregnall House (2662 Jasper Boulevard)

William S. Pregnall Sr. (1850–1914) built this as a beach house in 1911. He was raised, like his six brothers, in his father's business. He

Atlanticville

started out as a carpenter and worked his way up to superintendent of the Samuel J. Pregnall and Brothers Shipyard. As he built this house, he used doors and windows from the *Commodore Perry*, a former Confederate blockade runner that had been converted to a harbor ferry. When it was no longer in use, the Pregnall shipyard salvaged the scrap.

Unfortunately, the year the house was built a major hurricane hit the Charleston area and damaged it. Three years later, Pregnall died. Soon after, the shipyard closed. Pregnall's grandson, Eugene Pregnall Richardson (1913–1998), moved in during the Depression and raised his family here. He was a shrimper and later worked for the state flying a plane over the harbor to catch illegal shrimpers. He kept his boat near Breach Inlet and his plane very close to the house, landing right on the beach until an airport was built on the Isle of Palms where the golf course is today.

Continue straight and turn right onto Station 26. Follow it just to the end of the pavement and park. The best way to view this is to walk down the dirt roadway to the marsh. This is a good place to bird-watch. Ospreys are often seen fishing these waters, and the red-billed oystercatcher builds its home in the marsh. Occasionally, someone will still come out here and hunt marsh hens as they did a hundred years ago. There is also a great view of the bridge from here.

BEN SAWYER BRIDGE

This swing-span bridge was completed and opened to traffic in 1945. That year marked a lot of changes on the island. World War I was coming to a close, and soon the Military Reservation would empty of all its soldiers and shut its doors for good. But that didn't spell the end for the island's commerce and growth. In fact, veterans who fell in love with the island during the war drove back over the

Ben Sawyer, bought up the government property and helped create the town of Sullivan's Island.

Hurricane Hugo, which hit in September 1989, was a category five storm with winds so fierce that it spun the bridge and left it hanging at an angle. The Mount Pleasant side of the span sat tilted in the water until it was repaired over a week later.

Truesdell's Oyster Plantation

David Truesdell (sometimes spelled Truesdale) was at one time the single largest landowner on the island. He had a tract of marsh and dry land property that covered over two hundred acres. This was his oyster plantation.

In 1838 and 1843, Truesdell petitioned the state and requested permission to develop this northeast extremity of the island. There was a battle, however, between him and the citizens of Sullivan's Island and Christ Church Parish over the amount of property he attained and what he was planning to do with it. In 1786, the citizens of Charleston petitioned Governor Moultrie to keep the marshland and oyster banks as public lands and prevent anyone from monopolizing the oyster business there. Monopolizing the oysters would have been nearly impossible, since there are oyster beds all over Charleston. Nevertheless, restaurants and farmers were afraid of noncompetitive pricing. Truesdell himself owned two restaurants—one in Columbia and one in Charleston (the New York Oyster House at 32 Queen Street).

In 1853, a state commission was formed to investigate the land granted to Truesdell. The following year, he had to renew his petition for the land. The town officials on Sullivan's Island were against the lease, stating that it was against their corporate rights. Oystering was big business, not just for the restaurants but also for the lime produced from their shells that was used for building and fertilizer. Nevertheless, Truesdell succeeded in holding on to his plantation.

He had become quite an expert on oysters. In fact, he experimented with them and tried to create a hybrid oyster from the local raccoon oysters (as they were called in the 1800s) and oysters from New York. Taking a lesson from the rice planters, he used floodgates with brick abutments to control the tides so he could work.

John Beaufain Irving (1825–1877) was a Charleston artist and writer. In his *Local Events and Incidents at Home* (1850), he mentioned seeing Truesdell at work while he and his friends were on a fishing trip. He wrote,

> We witnessed an interesting spectacle as we passed along a little to the east of old Spanish Fort…David Truesdell, Esq., humbly engaged in his vocation at low water mark, separating and planting oysters,—"a Governor of the East," as he calls himself, that is, of the eastern part of Sullivan's Island; an F.R.S…a Fellow of the Royal Secret, or Master of the Royal Gastronomic Art of cooking shellfish to perfection—Fried, Roasted or Stewed!

Southern author William Gilmore Simms also knew Truesdell and called him a "patriarch of the oyster family." He wrote in 1849:

> He makes sea and shore equally tributary to his objects. One foot he plants in a field of okra, another in a field of oysters. The ocean breaks between his legs without disturbing his securities. He looks on the right hand and on the left, and feels that he is monarch of all he surveys…He has taken the unsophisticated muscle from his native bed, where he crouched and lived, rather than grew and flourished, and has given him a knowledge of the world. His protégés, under his benignant care, have grown to enormous sizes…How little do the gourmands at Columbia, during the Legislative session, conjecture the toil, the care, the watchful anxiety with which he has reared these young and artless creatures, that they may minister to the delights and appetites of the Statesman and the Politician…They tell me his oyster beds are no more safe than those of New Jersey. Report says that he has had to watch

A Tour of Historic Sullivan's Island

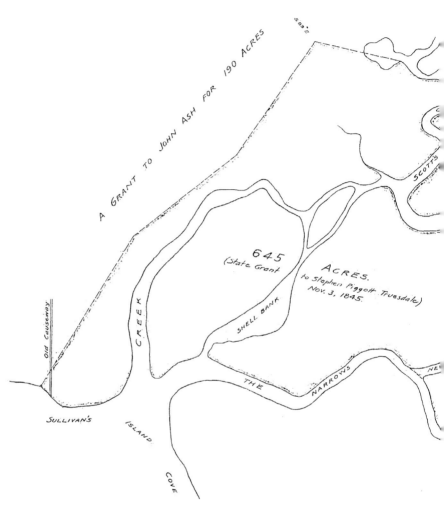

A map of Truesdell's Oyster Plantation next to the other "Truesdale" marsh property. *Courtesy of the County of Charleston.*

> them nightly, at low water, with a loaded blunderbuss…It cost the excellent proprietor, I am told, a matter of ninety dollars in advertisements against trespassers—announcing and setting forth his rights; sixty in blunderbusses and pistols,

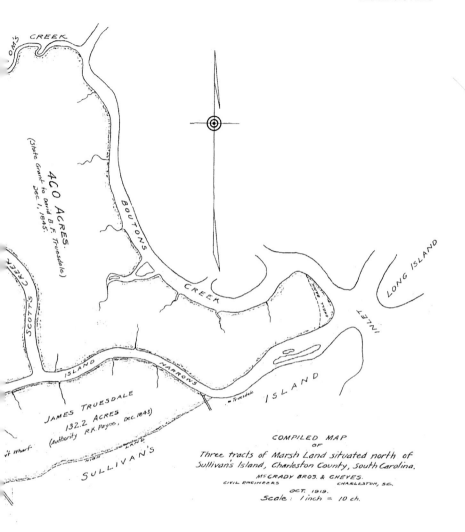

and some thirty more in shot and powder—to say nothing of the anxiety and loss of rest—in keeping his protégés from abduction...He certainly deserves [to be considered a benefactor] who can convert a raccoon oyster into a Blue

Pointer, or a Shrewsbury. We owe something of gratitude to Truesdell. Something is due also to the oysters. They have done the State some service.

Rare specimens of oyster shells were collected by Dr. Edmund Ravenel and others from Truesdell's oyster beds and are housed at the Charleston Museum and the Smithsonian Institution in Washington, D.C.

Head back down Station 26. Take the fourth right onto Middle Street. Look for the pretty little stone chapel on your right.

The Church of the Holy Cross (2520 Middle Street)

This is actually the third Episcopal church built on the island; the first two were in Moultrieville. This building was completed by 1908. The memorial windows, chancel and bell were removed from the previous building near Fort Moultrie and included in this structure. In the beginning, it was only used in the summer. During World War II, the building was used as a first-aid station for the fort. After the war, the fort's dental clinic was moved to this location for use as a parish hall. The congregation is part of the Episcopal Diocese of Charleston. The chapel is listed on the National Register of Historic Places as a contributing resource to the Atlanticville Historic District.

Continue straight down Middle Street and you will see the water tower to your right.

Atlanticville

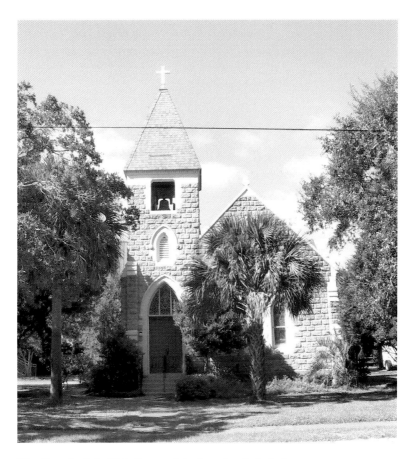

The Church of the Holy Cross as it looks today. *Author's photo.*

Water Tower

Standing at 120 feet high, the water tower was in place by 1938. It is built of steel and holds 100,000 gallons of water. It sits on the location of an old standpipe where residents could collect fresh water from a well. It is listed on the National Register of Historic Places as part of the Atlanticville Historic District.

A Tour of Historic Sullivan's Island

Almost directly in front of the water tower on your right, you'll see a house with three dormers and a brick foundation with brick steps.

2424 Middle Street

This was the childhood home of bestselling author Dorothea Benton Frank. She is a descendant of the Blanchard family. Two of her popular novels are *Sullivan's Island: A Lowcountry Tale* and *Return to Sullivan's Island*. This house is listed as a typical island house on the National Register of Historic Places.

On your left, about two doors down and across from the pink house, you'll see a house that looks like a little wooden church. This building is listed on a 1924 map as the Union Congregational Church. A few years later it was listed as the Central Union Church. It is now a private residence.

The diagonal street just ahead on your right is Quarter Street. It was originally part of Railroad Avenue, where the trolley ran from the cove to the Isle of Palms. There was a covered trolley stop here before 1924. The Triangle Grocery Store also stood here.

Bruggeman's Farm

There was a cantaloupe farm down the street at the corner of Jasper Boulevard and Station 24 run by Frederick William Bruggeman (1825–before 1900), a Prussian immigrant who came with his wife to South Carolina just in time to witness the Civil War. Their first son, Frederick, was born the year the war started. Their second son, Henry, was born four months before it ended. Four other children (including a set of twins) followed.

The Bruggemans were farming on the island by 1880. Henriette Lizette (1837–1930) and her son Henry took over the farm after her husband died. Island children enjoyed going to the farm on Sundays

Atlanticville

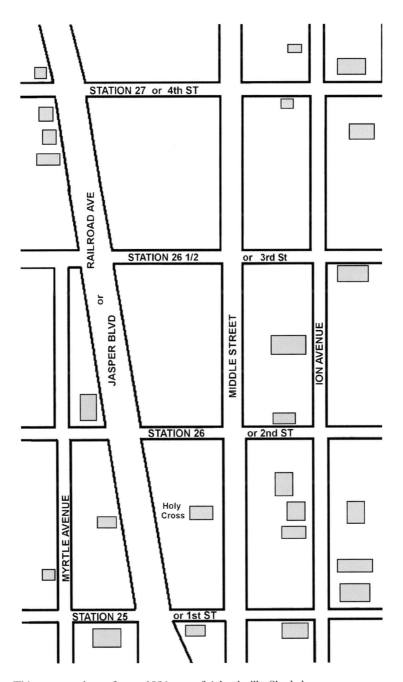

This map was drawn from a 1924 map of Atlanticville. Shaded squares are houses that still exist since the original map was made. *Author's photo.*

to buy the melons for only a nickel each. Henriette died of influenza at her home on Valentine's Day 1930. She was ninety-three years old. Her son Henry never married. He retired from farmwork and moved to Pitt Street in Mount Pleasant. He died in 1954.

Continue straight down Middle Street toward the intersection of Station 23. Notice the long building on your right at the corner.

Sullivan's Island Graded School (2302 Middle Street, "Block Away")

In 1925, this building became the first real school building on the island. It was completed to meet the growing population of permanent residents. Before then, children had gone to school in houses or in buildings donated by the fort.

In 1801, Mr. N. McCormick opened a school on the southern end of the island "during the sickly months," promising to attend to the children's "moral as well as their literary improvement." In 1817, the Sullivan's Island Academy advertised that it was opening for the season in June. In 1843, George Patten sold to J.M. Doe a house, a lot and a school lot. Two years later, the town council petitioned for a school and formed a committee on education. The citizens of the town requested a charter of incorporation to build a school because they had "removed to the island to avoid an outbreak of yellow fever in Charleston." There is no evidence, however, that the building was ever built. The Blanchard house at 2014 Central Avenue was used as a school from 1890 to at least 1910.

This building was in use as a school from 1925 until 1955. That year, a new building was constructed for Sullivan's Island School on property that was formerly part of the U.S. Military Reservation. Soon after, the Presbyterian congregation moved into this building, remodeled it and named it Sullivan's Island Presbyterian Church.

Atlanticville

This group remained here until 1977, when it moved into the newly constructed Sunrise Presbyterian Church across from Breach Inlet.

Continue straight on Middle Street to Station 22½. The original name of this street was Frost Street. The Frosts were a prominent family in the eighteenth century and included a rector of St. Philip's Church and a dean of the faculty of the Medical College (now the Medical University of South Carolina). Henry Rutledge Frost was on the board of directors of the Moultrie House in 1850.

There was a trolley barn here in the late 1800s where the horses were kept. The end of the line for those trolleys was at Station 22. It then ran all the way down Middle Street to the wharf at the cove. Horses pulled the trolleys across wooden rails in the sand. As the boards became bogged in the sand, the conductor got out and used a shovel to straighten them. It may have been tedious, but it was the only public transportation they had.

Turn right onto Station 22½. Pass Jasper Boulevard and Myrtle Avenue and look on your right for a cemetery before the bridge.

The Cemeteries

You'll see a historical marker here and a parking area to pull into. This African American cemetery has been here since about 1830. Slaves, free blacks and former slaves are buried here in unmarked graves. There is one marked grave from 1944. During the Great Depression, nearly one quarter of the population on the island was African American. The families included the Smalls, the Maybanks and the Germans. Thomas German was the watchman on the Cove Inlet Bridge. Walter and Rosa Maybank no doubt held an island record—having twelve children, none of which were multiples! He supported them as a janitor working at the fort. Eugene Potter, at

seventy-one, was a steamer pilot in 1930 and one of the few islanders old enough to have been around during slavery.

Turn left back onto Station 22½. Take your first right onto Myrtle Avenue.

On your right you'll see a sign for the Sullivan's Island Historic Cemetery, circa 1820. William Gilmore Simms wrote of seeing graves here in 1849. Prior to the Civil War, most people who died on the island were buried in church cemeteries in Charleston. The exceptions were mainly soldiers and slaves. But after the war, an increasing number of residents moved to the island and attended island churches year-round. James Truesdale, who was an oyster farmer like his relative David Truesdell, is buried here. There is also an attractive tombstone from 1861 dedicated to Thomas Knox from Ireland. The only person by that name on record in the area was a laborer. It's likely, then, that someone else paid for the expensive tombstone on his behalf. Like at the African American cemetery, many of the graves here are unmarked.

Continue straight to the intersection and turn left. On either side are small beach houses typical of those built at the turn of the twentieth century. Stop at the intersection of Middle Street.
 Station 22 was originally called Simons Street. It was the boundary line in the 1920s between Atlanticville and Moultrieville. Across the street and to the left was the site of the Breakers, a bowling alley and dance hall owned by the McCulloughs. Behind it was the site of the New Brighton Hotel.

New Brighton/Atlantic Beach Hotel

In 1884, J.F. Burnham opened the New Brighton Hotel on what is now Atlantic Avenue between Station 22 and Station 22½.

Atlanticville

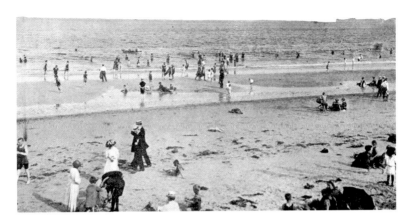

An old postcard of the area at Station 22. Turn-of-the-century beachwear left plenty to the imagination.

Back then, the street was known as Beach Avenue. The building contained three floors with 112 rooms, a spacious dining room, bathhouses (rented to non-guests for fifty cents) and a boardwalk on the beach.

In 1896, the McCulloughs purchased the property and renamed it the Atlantic Beach Hotel. The chief cook was a woman named Mattie Brown, an African American who came with the McCulloughs from Columbia and worked her way up from dishwasher. She and a staff of five worked at the hotel from April to September. The McCulloughs, however, continued to pay her through the off season. In the winter, she supplemented her income doing odd jobs at the fort and for island residents. Mattie left her job at the hotel in 1921 when she married, and the couple lived on Jasper Boulevard near Station 22½.

Four years later, the hotel burned down. The McGuire family (neighbors of the Browns) were at a dance there the night it burned. They had just returned home when they saw the flames light up the night sky. It was an event that would be long remembered.

53

On your left is a little house that is now a restaurant. The building was a private residence built before 1910 and owned first by the Barley family and then the Eldridge family. On your right is a little house that is now a fitness center. It was once owned by Joseph McInerny.

Joseph S. McInerny House (2120 Middle Street)

This was known at one point as "Old Man McInerny's house." It was owned by Joseph S. McInerny Sr. (1898–1982), a lifelong East Cooper resident. He was the second oldest son of Joseph P. McInerny (1870–1928) from New York. The elder McInerny moved to Sullivan's Island as a young man. He and his wife, Johanna, had seven children. Their home at 1820 Central Avenue was built in 1895, and ten years later a store was added in the back for selling lumber. Both of those buildings are listed on the National Register of Historic Places.

Joseph S. McInerny Sr. was born at Station 14, and his first job was working as a clerk in his father's store. He wrote that he remembered as a boy trying to hitch free rides on the back of the trolley cars to Mount Pleasant, although at the time, the fare was only three cents. He is remembered fondly by island baby boomers for giving out homemade fudge to children on Halloween.

Turn right onto Middle Street and park in front of the playground on your right.

Moultrieville

No scene can be more entrancing to persons in a particular mood of mind, than the one viewed by moonlight from the beach of Sullivan's Island. The long and sullen swell of the Atlantic, breaking upon the sands beneath our feet, and "the yellow beam" dancing merrily, upon the luminous waters.
—*John Beaufain Irving, 1850*

You are now entering the historic district of Moultrieville. This area is on the National Register of Historic Places and was the first town on the island, incorporated in 1817. It was home to "citizens and foreigners, soldiers and mariners."

Like Atlanticville, the town got its start in tourism. In fact, in 1809, it was quite a party place. That year, Governor John Drayton complained to the state's senate of the need for law and order here. He wrote,

> *It's contiguousness to the sea makes it easily audible to* [those] *who may be passing it in boats, & from them & many other circumstances, it is much exposed to disorder & deprivation…It is well understood on Sullivan's Island that the commissioners have no powers. The vicious & disorderly feel no restraints…The*

tipling & disorderly houses, and billiard gaming tables are openly visited to on Sundays, in defiance of the commissioners & all encligned to decorum.

From 1829 to 1844, the town repeatedly requested appropriation and funds to build a jail, citing civil disorders and complaining of escaped slaves and crime. The *Columbian Star* reported in 1829 that a soldier at the fort was "crazy from drink" and killed himself with his pistol. In 1843, W.K. Armistead, commander of the garrison, petitioned for a check on the sale of ardent spirits to his soldiers.

This part of Middle Street was once known as Beach Street in the 1840s and later East Middle Street. On your right is a grassy mound that is hard to miss.

Mortar Battery Capron/Battery Pierce Butler (The Mound)

This mortar battery took two years to complete. Mounted with four twelve-inch mortars, it was the first to be built on the island as part of the Endicott System of coastal defense. Upon its completion in 1898, President McKinley declared that it should be named Fort Capron in honor of Captain Allyn Kissam Capron (First U.S. Volunteer Cavalry). Capron was one of Theodore Roosevelt's celebrated Rough Riders during the Spanish-American War. He was killed in the Battle of La Quasina in Cuba the same year this mortar battery was completed. Roosevelt said that he was an ideal officer and "the best soldier in the regiment." Witnesses reported that when Capron was wounded, he said, "Don't mind me boys, go on and fight," as he struggled to witness the rest of the battle. Capron's body was brought back to the United States and buried at Arlington National Cemetery.

Battery Pierce Butler was added to Battery Capron with another four mortars by 1906. It was given its name that year by the War Department in honor of Colonel Pierce M. Butler (Palmetto

Regiment, South Carolina Volunteers). He was a former governor of South Carolina who was killed in action leading the charge at the Battle of Churubusco, Mexico, in 1847. Many of his men were wounded or killed in the Mexican War. Some volunteered once again at Fort Moultrie to fight in the Civil War.

Behind the mound on the marsh side were a guardhouse, engineer's storehouse, cistern, powerhouse and small barracks. During hurricanes, the mortar battery was used by islanders as a shelter from the high winds. Generations of children have used this as a giant slide ever since. Climb to the top and enjoy the view.

Across the street is Station 21, originally called Ravenel Street. It was named for Dr. Edmund Ravenel (1797–1870), who was a founder of the Medical College of South Carolina and had a house in Moultrieville. As a conchologist, he collected over three thousand species of shells. Some of his specimens taken from Sullivan's Island are at the Charleston Museum and the Smithsonian Institute.

Bandstand

This structure was built in 1905 at Station 17 between the beach and Officer's Row. It was moved to Thompson Avenue in the 1950s and then to this location.

Station 20½ was once Horry Street, named for Captain Peter Horry, who fought at Fort Moultrie in 1776. On the corner is a long building that contains a restaurant, convenience store, art store and dry cleaner. After World War II, Burmeister's Variety Store took up most of this building. It sold everything from clothes to magazines. It was also a gathering place, having a soda fountain and tables. Sharing the building, where the dry cleaner is now, was a liquor store for those looking for more spiritous drinks.

Head down Middle Street once again and turn left onto Station 20½.

A Tour of Historic Sullivan's Island

This map was drawn from a 1924 map of Moultrieville. Shaded squares are houses that still exist since the original map was made. *Author's photo.*

Battery Thomson (2013 I'on Avenue)

Construction on this coastal defense battery began in 1906 and took three years to complete. It is over three hundred feet long, ten feet high and once held two ten-inch guns. The types of guns used here were superior in accuracy to those on battleships at the time and were mounted on platforms that disappeared into the battery to protect the guns and those loading them. Inside the concrete structure, rooms held gunpowder, shot and machinery. Soldiers climbed spiral staircases to get out onto the upper level. The battery, named for Colonel William Thomson, was decommissioned and cleaned out of its equipment in 1947.

For decades thereafter, it was left vacant and was a favorite place for local children to explore and scare one another in its dark corridors. In the 1970s, Boy Scouts used it as a meeting place, and the town had considered using it as a public library before deciding on the neighboring Battery Gadsden. Today, it is a training facility for the Sullivan's Island Fire Department and is listed on the National Register of Historic Places.

Battery Gadsden (2017 I'on Avenue)

Like its neighbor, Battery Gadsden (named for Patriot Christopher Gadsden) was built as part of the coastal defense system known as the Endicott System. This massive construction program began installing batteries like these all over the U.S. coastline in 1886. This one was completed in 1904. It is about fifty feet longer than Battery Thomson but only seven feet in height. It held four six-inch retractable guns. Its lifespan was also much shorter than its neighbor; its guns were removed in 1917. A caretaker was then put in charge of the structure. His house was between here and Battery Thomson. This structure is currently used as a Charleston County Public Library and the Make MacMurphy Cultural Center.

In front of Battery Gadsden is a historical marker commemorating the Civilian Conservation Corps, a Depression-era work relief program designed to employ young men in restoring forests and building recreation areas. One islander who worked for the corps said that toward the end of the program as the men ran out of work, they just dug holes and filled them back up again.

Turn right onto Station 20. This was originally Pinckney Street, named for Thomas Pinckney, who spent a lot of time on the island. He was a Revolutionary War veteran and became governor of South Carolina and a member of Congress, and he negotiated a treaty with Spain that gave America access to the Mississippi River.

In 1916, several families on this street made claims against the government for damage done to their property by the testing of nearby guns. The noise was so loud that it shook the houses of the Blanchard, Jahnz and McGolrick families enough to cause structural damage.

Turn left onto Middle Street. The second house to your right on the corner is actually a former gatehouse.

Devereux Mansion Gatehouse (1914 Middle Street)

John Henry Devereux was a Charleston architect who constructed a stately mansion and this gatehouse in front of it in 1875. The elaborate main house once dwarfed all others on the island, but it is no longer standing today. Among the public buildings Devereux designed in Charleston are the U.S. Post Office (1896) on Broad and Meeting Streets and St. Matthews Lutheran Church (1872). He was also hired to remodel homes on South Battery.

Turn left onto Station 19, originally called Wharf Street. Turn right onto I'on Avenue. On your left you'll see the Coast Guard station and lighthouse.

Moultrieville

U.S. Coast Guard Station and Sullivan's Island Light

This area is listed on the National Register of Historic Places. It began as a lifeguard station in the 1890s, when people lounged at the beach covering more skin than they exposed. The white house on the corner with the red roof and cupola was the station house. The smaller building with the weather vane on top was the boathouse. Both were completed in 1891. The bunker was built seven years later.

The iconic Sullivan's Island Lighthouse in 1962. *Courtesy of the Library of Congress.*

Two men from the island gave their lives to save others in the service of this station, and they are listed in the Boat Forces Memorial of the United States Coast Guard. They are James J. Coste, surfman (August 19, 1898), and Michael T. McGuire, surfman (September 4, 1903). The Coste family has a long-standing maritime tradition. Captain Napoleon L. Coste (1809–1885) was a sea captain, and Vincent O. Coste was in the Coast Guard in the 1920s.

The present lighthouse was built in 1962. The triangular shape was used to make it more wind resistant than the traditional circular shape. When it was completed, it was the second brightest in the western hemisphere. The twenty-eight million candlepower, however, was a bit much for residents, who found it hard to sleep at night with the terrible glare. The light was soon reduced by more than 95 percent after repeated complaints. Nevertheless, on a clear night its light can be spotted by ships twenty-seven miles away.

Turn right on Station 18½. This street was originally named Patrick Street in honor of Dr. John Burckmeyer Patrick (1823–1903), a Charleston dentist. The octagonal house he built is on your left.

Octagonal House (1820 I'on Avenue)

The same year he built his own house on Middle Street in 1870, Dr. Patrick also built this house. It has a whimsical octagonal shape and was intended as a clubhouse for his sons. Patrick and his wife, Sarah, had a large family, even by Victorian standards. There were five sons, four daughters and an unmarried sister and brother living with them (no doubt to help out). It's no wonder, then, that it took two houses to hold all of them. At least one son, Charles, became a dentist like his father. Both houses built by John B. Patrick are now listed on the National Register of Historic Places.

Moultrieville

Approach the intersection of Middle Street. The first large house across the street on the left was Dr. Patrick's main beach house.

John B. Patrick House
(1820 Middle Street)

Dr. Patrick built this large beach house about 1870. His primary residence was on Society Street downtown. Patrick was president of the fledgling South Carolina State Dental Association, the membership of which was small enough to hold its annual meeting in his office downtown. Dr. Patrick was a mentor, inventor and contributing writer to journals on dentistry. He filled cavities with sterilized hickory wood wrapped in tinfoil. (Don't try this at home.) His articles, however, were certainly not for the layman. In his *Origin of Pus* (1892), he wrote, "Of all the topics that could possibly engage our attention, the history of pus, in the light of modern science, is the one which comes most directly to the front…of our pathological

The John B. Patrick house (circa 1870) as it looks today. *Author's photo.*

science." If your stomach can handle it, you'll find the rest of this article in the *American Journal of Dental Science*.

Turn left onto Middle Street. Notice the next house after the Patrick house.

Henry Siegling House
(1814 Middle Street)

The Sieglings were a musical family. The patriarch, John Siegling, immigrated to America and opened the Siegling Music House in 1819. As the family legend goes, he chose Charleston because the only other ship sailing that day was going to St. Petersburg, Russia. Siegling imported the finest instruments made in Europe and sold them in his store on King Street. Of course, his own home was furnished with a pianoforte and a melodeon. His daughter, Mary Leclercq, was an accomplished singer and musician who performed all over Europe and the Americas. His son, Henry, took over the Siegling Music House in the 1860s. It was Henry Siegling (1829–1905) who built this house in 1895. As a son-in-law of Dr. John B. Patrick, he had no doubt been a guest next door before he built this house.

Continue to the next house on your right.

William Gaillard Mazyck House
(1808 Middle Street)

W.G. Mazyck was from one of the oldest families in South Carolina. He was born in Cordesville in 1846 and was a member of the Second Battalion South Carolina Volunteer Troops. He began

Moultrieville

working for the railroad during the Civil War and rose up in the ranks of the railroad industry from the machine shop to treasurer. He was a historian for the Huguenot Society and curator of the Charleston Museum. He devoted his time to uncovering the missing names of those who died on the *Hunley*. He was also a conchologist. This beach house was built in 1911 and is listed on the National Register of Historic Places.

Station 18 was originally named Petigru Street in honor of James L. Petigru, a Charleston attorney who frequently summered here with his family in the 1800s. His daughter, Susan Petigru King, was an accomplished writer. She wrote *Busy Moments of an Idle Woman* in 1854. Her father suggested that she use a pen name given that so many characters were too similar to their friends and acquaintances.

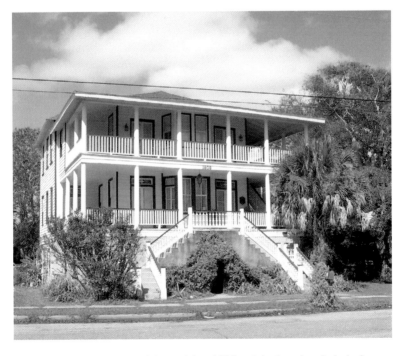

The William Gaillard Mazyck house (circa 1911) as it looks today. *Author's photo.*

A Tour of Historic Sullivan's Island

Rear Entrance of the Fort Moultrie Military Reservation

This rear entrance to the reservation was constructed in 1920. The masonry walls are topped with artillery shells and adorned with a bronze plaque. The front entrance was on the other side of the historic Fort Moultrie.

Turn left onto Station 18. You are now entering the former Military Reservation. The large two-story building on your immediate right was the bachelor officers' quarters (BOQ), built in 1900 to accommodate the rapidly increasing number of soldiers. In recent years, it was renovated and sold as residential condominiums.

Turn right onto I'on Avenue. You'll find an idyllic little neighborhood tucked away.

Officer's Row (1702–1760 I'on Avenue)

This shady drive, idyllic and picturesque, is one reason why Sullivan's Island has been called Mayberry by the Sea. If this street doesn't evoke fantasies of lazy summer evenings on a porch swing, I don't know what does. These houses were all built in 1905 for senior officers stationed at the fort and their families. When they were first occupied, they had no shade trees and a clear view of the beach.

Continue down Officer's Row to the end at Station 17. The largest of the houses at the corner here was designed for the base commander. The one next to it had been destroyed by a fire and was rebuilt in 1988 to match its neighbors as the original did. All eleven private residences are listed on the National Register of Historic Places.

Turn left onto Station 17. At the end, turn left onto Atlantic Avenue. Look for a large clubhouse on your right.

Moultrieville

The Sand Dunes Club (Atlantic Avenue)

This building was completed in 1934 as an officers' club called Jasper Hall. It was named after Sergeant Jasper of Revolutionary War fame. South Carolina Electric & Gas Co. acquired the land in 1953. It is now a club for the company's employees and can be rented out for parties.

Continue straight toward the lighthouse. At the stop sign, turn left onto Station 18. Turn left again onto Middle Street. Pass through the rear entrance of the fort and look to your right.

Sullivan's Island Baptist Church (1753 Central Avenue)

Located near the back entrance of the former Military Reservation, this church was built in 1944 as the post chapel for Fort Moultrie. When the fort was decommissioned, the property was purchased by the Baptist congregation for $4,500. They expanded and remodeled it over the years, adding a brick veneer to the outside. A former nurses' barracks is now a Sunday school building, and a cistern is used for office space. This site is listed on the National Register of Historic Places.

Noncommissioned Officers' Quarters (1742–1754 Middle Street)

This row of uniform dwellings located right past the church was built in 1905 for junior officers stationed here and their families. The married enlisted men's quarters were located on Thompson

Avenue. Houses built by the government for military families had indoor plumbing long before many of the civilians' island homes did. These are all private residences today and are listed on the National Register of Historic Places.

Continue on Middle Street. On the right across from Florence Street is a large home with pairs of Greek columns.

Post Exchange (1714 Middle Street)

This unique residence is also listed on the National Register of Historic Places. It was built in 1906 as the Fort Moultrie Post Exchange. It also had a gymnasium where the young soldiers off duty could let off steam. In the summer of 1910, it was the site of the brutal homicide of Private Henry Frye. He got into an argument inside the building with a fellow soldier of the 144th, Private J.T. Murray. The fight was taken out to the street, where Frye was beaten to death. Murray was sent to the post jail and court-martialed.

Continue straight a few yards to the next intersection at Station 17. Notice the large two-story building on your left.

Administration Building (1701 Middle Street)

This building was the administration building for the government reservation. It was constructed in 1900 during a major expansion of the coastal defenses on the island. It has been converted to apartments and is listed on the National Register of Historic Places.

Moultrieville

Station 17 was originally Laurens Street, named for Henry Laurens, a rice planter and a signer of the Articles of Confederation. Station 16½ was originally Marion Street, named for Brigadier General Francis Marion, the "Swamp Fox" of the Revolutionary War. On the corner of Station 16½ at left is a house that faces that street.

Provost Marshal's Office/Dispensary (1617 Middle Street)

This structure was built in 1900. It was, at different times, the headquarters for the military police and the place where soldiers could get medicine. The most dramatic event in the history of this building was the Spanish flu pandemic of 1918. More Americans died of influenza during the pandemic than died in World War I. Young adults were particularly vulnerable to this strain of the virus, which meant that America's forts were hit especially hard.

The first cases of Spanish flu in South Carolina were recorded at Camp Jackson, Columbia, where new recruits were trained. The virus spread quickly through the barracks and from fort to fort as transferred soldiers unwittingly carried the virus with them. The rising death toll among soldiers caused a certain amount of paranoia. Rumors of German conspiracy spread through Fort Moultrie as quickly as the virus did. Out of fear that European immigrants who joined the National Guard might be sympathetic to Germany, the Corps of Intelligence Police had been established the previous year as a countersubversive organization. Two men in each company were instructed to secretly observe their peers and report any suspicious activity. William R. Wilhauer, an island resident who was in the National Guard here at the time, even went so far as to put barrels of apples under guard when it was believed that they had been intentionally tainted with the flu virus.

The dispensary was later moved to a larger building across from Fort Moultrie. This building is on the National Register of Historic Places.

A Tour of Historic Sullivan's Island

Sullivan's Island Town Hall/ Quartermaster's Warehouse and Office (1608, 1610 and 1618 Middle Street)

This brick warehouse was built in 1915. Located near the northern terminus at Station 16, it housed food, supplies and equipment for the government reservation. According to the U.S. Census records, there were over 470 soldiers on the island operating the half-dozen new batteries in 1910. The quartermaster's job was to meet the supply needs of all the military installations and support facilities on the island. J.M. Fulton was the quartermaster during the expansion. He was also responsible for contracting construction work on the reservation and dredging in the cove. His office was at 1618 Middle Street, a structure that is now a private residence and (like this building) is on the National Register of Historic Places. The building at 1610 Middle Street became the town hall in the 1970s.

The original name for Station 16 was Jasper. Here at the cove was the northern terminus for the government reservation. The quartermaster dock, which was built in 1916, is still here. Until the Cove Inlet Bridge was built, this was an entrance onto the reservation. So there was also a guardhouse here. The brick warehouse on the corner of Station 16 and Thompson Avenue was built in 1930. Thompson Avenue was originally called Cove Street or Central Avenue.

Continue straight on Middle Street to Station 15. This street was originally Sumter Street, named for General Thomas Sumter, the "Gamecock" of the Revolutionary War. He was at the Battle of Sullivan's Island in 1776 with General Moultrie. Sumter is best known for his guerilla fighting tactics, which he learned from the Cherokee in the backcountry. He was elected to Congress in 1789 and, at the age of ninety-eight, became the last surviving Revolutionary War general. Fort Sumter is also named for him.

Continue on Middle Street a few yards until you see two brick buildings on your right.

Moultrieville

Noncommissioned Officers' Club and Post Theatre (1450 Middle Street)

Life at the fort wasn't all drills and training. The smaller of the two brick buildings here was constructed in 1925 as the noncommissioned officers' club. It was sold to the town in the 1950s and was the Sullivan's Island Town Hall until 1975 and then used by the fire department. It is privately owned today.

The larger building was the post theatre. It was completed in 1930. That year, soldiers were likely treated to a showing of the new movie *All Quiet on the Western Front*, which garnered Oscars for best production and directing at the Third Annual Academy Awards. These two buildings are listed as part of the Fort Moultrie Quartermaster and Support Facilities Historic District on the National Register of Historic Places.

Station 14½ was originally Moultrie Street, named for William Moultrie and the fort that took his name. Continue straight and look for a stone building that looks like a castle on your left.

Post Chapel (1401 Middle Street)

This was the first site of the Church of the Holy Cross. Completed in 1892, it became a post chapel for Fort Moultrie when it was purchased by the government in 1905. After World War II, it was sold to the Evangelical Lutheran Synod of South Carolina, which used it as St. Marks Lutheran Church for several years. It was sold in 1979 and is now a private residence with a medieval castle theme.

Station 14 was Accommodation Street, likely named for the hotels and boardinghouses in this area during the 1800s.

A Tour of Historic Sullivan's Island

Site of the Moultrie House

The area toward the beach between Station 14 and Station 13 is the approximate site of the Moultrie House. The hotel opened its doors on July 8, 1849. It was built by a group of investors led by H.W. Conner, Esq. Edward C. Jones was the architect. Irving wrote that it was "at once elegant in its construction, and admirably suited to the purpose, for which it is intended, and is put together at the same time so strongly, as to render it storm proof."

Sitting on eight acres, the hotel was said to be over two hundred feet long and forty feet wide, easily accommodating two hundred guests. There were piazzas on the first and second floors and an observatory on the roof. It had a large ladies' boudoir, or sitting room, with a piano. It also had a ballroom, the windows of which stretched to the floor.

Covered bathhouses were available to "those who are disposed for a bath at any time in the surf." Two large cisterns with pumps provided water by windmill to the kitchen and patrons of the hotel. The cost to build and furnish it was $32,000. The building was destroyed during the Civil War, being directly in the line of fire. Abner Doubleday was among the first to inflict damage to it with two forty-two-pounder balls, joking that being given a bad room in the past justified the act.

These soldiers stayed in the Moultrie House during the first weeks of the Civil War. *Courtesy of the Library of Congress.*

Moultrieville

Continue toward Fort Moultrie. Palmetto Street was simply known as East Fort, and Poe Avenue was the original Atlantic Avenue. The name was changed in honor of Edgar Allan Poe, who was stationed at Fort Moultrie.

Station 13 was called Lighthouse Street. John McGuire, an Irish immigrant, had a bakery here in the late 1800s. Station 12, next to Fort Moultrie, was West Fort. A 1912 map shows a small building on the fort side of this street that housed the Moultrieville post office (established in 1875) and the town hall.

Continue toward the church on your right.

STELLA MARIS CATHOLIC CHURCH (1204 MIDDLE STREET)

The first Catholic church on the island was the Church of St. John the Baptist, a simple wooden structure built near this site in the 1840s under the direction of Dr. Timothy Bermingham. Construction on the building that stands here now began after the Civil War using bricks from the damaged fort. This Victorian Gothic building was completed in 1873 also under the direction of Bermingham. Sadliers' Catholic Directory stated in 1872, "When finished, it is hoped it will be an attractive object on an island memorable for two wars."

This second building was first named St. Mary, Star of the Sea, but was later simplified to the Latin name Stella Maris. In keeping with the nautical theme, the ceiling inside the church is shaped like the hull of a ship. Stars were originally painted against a blue background on the ceiling above the altar and can still be seen behind the choir loft where the bells are rung. Vibrations from artillery practice at the neighboring fort during World War II did extensive damage to the window glass. The current stained-glass windows were installed in 1955. This building is listed on the National Register of Historic Places.

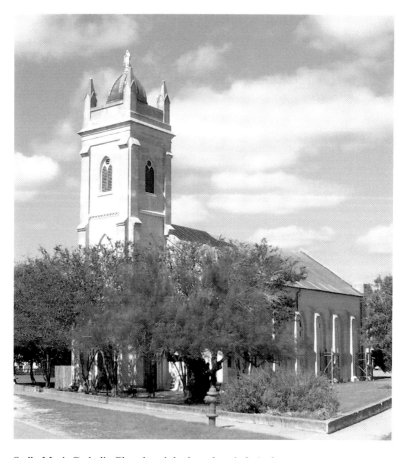

Stella Maris Catholic Church as it looks today. *Author's photo.*

Continue on Middle Street, staying to the left of the fork in the road.

Some of the houses in this area date to as early as 1830. Many of them were used during the Civil War by Confederate soldiers. Not all the houses survived bombardment or the treatment they received from the soldiers. Reverend Charles Cotesworth Pinckney was the grandson of Thomas Pinckney. In 1895, he wrote of his grandfather's elegant summer home:

Moultrieville

It was an admirable plan for a home in our climate. Two stories high, on an elevated foundation, its capacious rooms almost all faced the south, and got the refreshing breeze which ever blows from the sea. The double stairway, descending on each side of the semi-circular room in the rear, was not only easy of ascent, but positively ornamental with its graceful curve and mahogany railings…He built a bathing-machine on wheels, after the pattern of those which he had seen on the coast of France, which was rolled into the surf, and drawn up by windlass when the bathers gave the signal. Few were the days in which he did not recruit his strength by a dip in the invigorating waves of the Atlantic. His bathing-machine was as prominent a feature on the beach as his house was on the island. After resisting three great hurricanes of this century, the [house] was pulled down during the Confederate war, ostensibly because it interfered with a battery; really because fuel was scarce, and the soldiers obtained authority to complete the work of destruction which they had already begun. General Pinckney was patriotic, but I doubt whether he would have sanctioned this ruthless act.

Of the destruction he saw after the war, one writer said in 1870, "Landing at the wharf, and walking up the back beach, you can still recognize the island, but on the front beach nothing looks as it did before the war, or even after the first battle of Fort Sumter. The palmetto trees…like battered warriors, with many a scar of shell and bullet, remain so many veteran witnesses of the raging conflict of which there is no sign in the stillness that surrounds them." Right after the Civil War, as the island struggled to get back to normal, the Surf House was built next door to the fort to encourage visitors to come once again to the beach.

On the left just before Station 11 are two houses that are difficult to see through the vegetation but can be seen from the beach. They were built after the Civil War by the same man.

A Tour of Historic Sullivan's Island

Several steamers like this one ran aground in this area during the Civil War. *Courtesy of the Library of Congress.*

1103 and 1109 Middle Street

These homes were built in 1867 by Judge William Hiram Brawley (1841–1916). He was in the Confederate army until 1862, when he went home to manage his family's plantation. He later became a congressman (1891–95) and a U.S. district judge (1894–1911). Brawley built the first house here for himself. His primary residence was South of Broad on Legare Street in Charleston. The house at 1109 Middle Street was built for his daughter and son-in-law.

On your right is a beach house that is rivaled only by the C. Bissell Jenkins beach house built in Atlanticville about the same time.

Cosgrove House (1102 Middle Street)

This exceptional beach house was built in 1890 by the son of Irish immigrants, James Cosgrove Jr. (1861–1911). He started his career as an accountant in his father's store in Charleston and attained his wealth in real estate. A civic-minded man, Cosgrove was also a state senator, a member of the South Carolina Good Roads Association and a member of the Knights of Columbus. But he was most appreciated by his contemporaries for his role as secretary and engineer of the Sanitary and Drainage Commission. Dubbed the "Apostle of Drainage and Good Roads," Cosgrove was highly praised for draining wetlands to create dry roads, usable land and a healthy environment. Though it may seem environmentally irresponsible to us today, in an era when thousands across the southern United States were still dying of mosquito-borne illnesses, getting rid of acres of marshland seemed like a good idea.

Cosgrove married his wife, Matilda, in 1897 and built this house as a second home. His main residence was on King Street in Charleston. The couple had no children, so they shared this spacious home with boarders. At the age of forty-nine, Cosgrove was seeking treatment at Johns Hopkins Hospital in Baltimore when he lost his battle with liver cancer. After her husband's death, Matilda continued to rent out rooms to boarders like Father Bernard Fleming, the priest at nearby Stella Maris Catholic Church.

Station 11 was called Quarter Street. The next house on the corner was raised and renovated in 2009.

1026 Middle Street

Built in 1850, this was the beach house of the Aimar family. The G.W. Aimar Drug Company was a family-owned business that was founded in Charleston in 1852 and lasted for over one hundred years. It was the official dispensary of the Confederacy during the Civil War.

The success of the business is no doubt due to the dedication of the family. Generations of Aimars were pharmacists at the company. In fact, G.W. Aimar Drug Company remained in the family until it closed in 1978. The contents of the store were purchased by the Smithsonian Institution in Washington, D.C., where prescription books and formulas dating back to 1864 can be found. Among the medicines sold in their store in Charleston during the nineteenth century was a topical solution called Pearson's Rheumatic Relief and Fire Extractor.

Three houses on the left (1001–1013 Middle Street) were all built by 1850. Station 10 was originally called Shell Street. Just past Station 10 on the left is another house that is difficult to see. At 957 Middle Street, this building was listed as a Presbyterian church in the 1890s. The Holiday House opened here in 1907 as a place for impoverished parents to bring their children for summer camp. Operated by the Episcopal Diocese, it was open from July through September.

Station 9½ was Hale Street. Station 9 was Point Street and then State Highway 703. This is where the trolley cars arrived on the island from Mount Pleasant and then turned down Middle Street heading east toward the Isle of Palms.

On the left about one hundred feet down Middle Street from Point Street as you go toward the harbor, there was once a small street called Church Street. This was the site of the original Episcopal church on the island.

Grace Church

George H. Spieren is the first Episcopal clergyman on record to officiate on Sullivan's Island. He retired after the death of a beloved son "ailed his mind with deep melancholy." He died here in 1804 of a fever and a broken heart.

Since there was only a very small population on the island, most of whom were here only in the summer, there wasn't a proper church building until 1819. The first Episcopal church on the island

Moultrieville

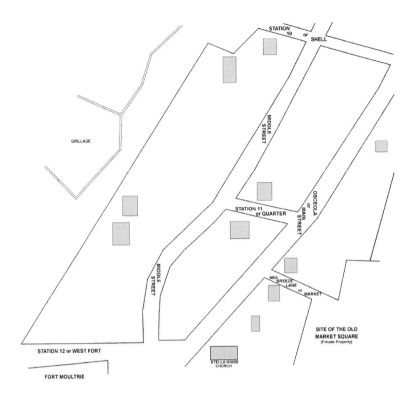

This map was drawn from a 1924 map of Moultrieville. Shaded squares are houses that still exist since the original map was made. *Author's photo.*

was Grace Church, which was established by Dr. Theodore Dehon (1776–1817). Dr. Dehon was a native of Boston, a Harvard graduate (class of 1797) and received a doctorate from Princeton in 1809. The following year, he came to Charleston to take over the pulpit of St. Michael's Church (which is open to the public and still very much an active church).

Dehon was said to have been as handsome as he was intelligent. He married Sarah Russell, a daughter of one of the wealthiest men in Charleston, Nathaniel Russell (whose home is also open for tours). In 1817, Dehon purchased the brick lazaretto and began acquiring furniture for it. He died of a fever that year at the age of forty-one before he could consecrate the building. Dr. Christopher Edwards Gadsden wrote in 1833,

> *Perhaps, at this time, he had a persuasion that the stranger's fever, as it is called, would visit him, and that he might be its victim. On the last day of his health, he was at Sullivan's Island, occupied in directing the workmen how to arrange the pews in the Church. The establishment of a church at this place of refuge for strangers to our climate, and of resort for many of our citizens, in the summer, was a purpose he earnestly desired, and its accomplishment is chiefly to be attributed to his influence and exertions…Bishop Dehon set forward a subscription, contributed liberally, and affected the purchase of a public building, which has since been converted into a neat and commodious church, and duly consecrated, under the name of "Grace Church."*

In the brief time that Dehon was here, he made such an impression that his congregation on Sullivan's Island erected a stone tablet in his honor that once stood along the eastern face of the brick church.

Historian Frederick Dalcho commented in 1820 that Grace Church was "fitted up with much neatness, and it commodiously pewed. The Bible, was a donation from Mrs. Mary Peters, the Prayer Book for the Reading Desk, from Mrs. Margaret Bethune; and two Prayer Books for the Altar, were presented by Mrs. Valk. At present, the only piece of Communion Plate is a chalice."

The poet Caroline Howard Gilman wrote a poem in 1838 titled "Thoughts at Grace Church, Sullivan's Island." Of her visit here she wrote, "There is something deeply impressive in the low murmurs of the summer ocean mingling in with man's tones of penitence and thanksgiving, while the waves, the winds, the flowers, the birds speak their language of natural joy."

Lazaretto

As mentioned, the church was built from the lazaretto that once stood near here. The term "lazaretto" is derived from the Biblical Lazarus and the ancient Order of the Knights of St. Lazarus, which

Moultrieville

built a leper hospital just outside of Jerusalem during the Crusades. The first building on this site was a simple wooden structure used by colonial Charles Town as a quarantine location for immigrants and slaves. It provided little protection from the elements and was swept off the island by the hurricane of 1752, the most violent storm since the founding of the town.

A brick building was later erected by the British during the occupation of Charles Town (1780–83). In 1786, Captain Simon Tufts was placed in charge of Fort Moultrie and its surrounding public buildings, including the lazaretto and warehouse. Tufts was a Revolutionary War veteran who served as a captain in the navy. He was to live on the island and receive fifty pounds sterling a year, which was paid out of the port taxes. When, in 1804, another devastating hurricane flooded most of the island and destroyed twenty houses, the brick lazaretto provided a safe haven.

Disobeying the quarantine laws was punishable by imprisonment and/or a heavy fine. On December 5, 1793, Francis Grice requested that he not be fined five hundred pounds sterling for boarding a ship under quarantine on Sullivan's Island. He was eager to see his wife and child, who were onboard, and was unaware of the quarantine. Fortunately, the penalty was lifted.

In 1795, Tufts complained to the state that people were building houses too close to the lazaretto and requested that they be removed. It was suggested by the legislature that year to build a new quarantine station somewhere else on the island. A few years later, at the insistence of summer residents, the pesthouse was moved to James Island. The $5,300 it cost to build a new pesthouse across the harbor was charged to Sullivan's Island residents via a property tax. The brick building was later sold to the Episcopal church.

Follow Middle Street to the end and turn right onto Conquest Street. This street originally led to the steamboat launch. John Beaufain Irving wrote of Hilliard's Line of Steamers in 1850, "As the fare now is only ten cents to Sullivan's Island, the temptation to frequent change of air is irresistible, with all sorts and conditions

of our people…The names of the different boats, which constitute the Line, of which we are now speaking, are *The Coffee, The Mount Pleasant, The Hibben,* and *The Massasoit.*" Passengers left from Market Street downtown and arrived here at the tip of the island. Carriages were available for hire, or day-trippers could bring their own horses for "an afternoon or moonlight ride upon the beach."

On your left is a private boat landing. Just next to it can be seen the site of the old bridge between Mount Pleasant and Sullivan's Island.

Cove Inlet Bridge (aka the Old Bridge)

The first bridge here was a pontoon bridge built in 1776 at the instruction of Major General Charles Lee in preparation for the famous battle that took place between the Patriots and British on June 28 of that year. It was also used by the British during their occupation of Charleston.

In 1898, a drawbridge was constructed for trolley cars to carry passengers from Mount Pleasant to Isle of Palms. In 1926, planks were attached across the tracks to convert it for automobile traffic. For this reason, it was said to be very rickety.

Continue straight and the street turns into Osceola Avenue, previously called Main Street and Cove Street. On your left, you'll see Seabreeze Lane running toward the cove. This was originally Market Street. There was a market building at the end of this road in the 1800s. The earliest market was constructed about the year 1800 with living quarters for a small family. The area is now private property.

Continue straight down Osceola Avenue to Middle Street. Turn left into the parking lot of Fort Moultrie.

Fort Moultrie

Fort Moultrie with its gateway, and its narrow postern, and its ramparts, well provided with wall pieces, call up the usual associations of the patriotic Past.
—*John Beaufain Irving, 1850*

Fort Moultrie is owned and operated by the National Park Service as part of the Fort Sumter National Monument. The museum has been open for tours since the 1970s. Roughly 100,000 people visit the fort annually. As you walk around, you're encouraged to stay on designated pathways, since there are areas where a person could get hurt if he's not watching his step.

The first thing that you should do once you park your car is walk to the dock on the cove. For well over two hundred years, the only means of transportation the soldiers had to Mount Pleasant and Charleston was by boat. Fort Moultrie had several wharves at various times on the island and maintained its own boats.

From here, you get a nice view of the Ravenel Bridge, North America's longest cable stay span. It was actually completed a year early, in 2005. (Don't worry, it's not because they cut corners.) Spending as much of the money as possible here at home, steel for its construction came from Georgetown, South Carolina.

Before the first bridge (John P. Grace Memorial Bridge) was built across the Cooper River in 1929, East Cooper residents took ferry boats to Charleston. Island residents left from a wharf closer to the point at Station 9. After the trolley bridge was built in 1898, they traveled by trolley to Mount Pleasant and then took a ferry downtown. It made for a long commute. Those who had the option (military families and relatives of the engineers) took the government boats directly from the government wharf.

Atlantic Intracoastal Waterway

Passing between Sullivan's Island and Mount Pleasant is a highway of interconnected rivers and canals that runs the entire length of the Atlantic Seaboard from Miami, Florida, to Maine. Colonel William Byrd II proposed a canal connecting North Carolina and Virginia in 1728. It was not begun, however, for another sixty years, when Virginia authorized construction of the Dismal Swamp Canal. According to the Atlantic Deeper Waterways Association, an intracoastal waterway was a matter of national security. In 1912, the organization had a vice-president and delegate in every state on the East Coast to help bring about its construction. By this time, the coastwise sailing fleet was becoming obsolete, and barge traffic was taking over. These vessels performed better, however, on inside passages. In the first decade of the twentieth century, more than five thousand vessels were damaged or lost off the Atlantic and Gulf Coasts, resulting in the loss of two thousand lives and $40 million in damages to vessels and cargo. After extensive surveys and recommendations, the southern section was approved by the Sixty-third Congress in 1913.

At last, the Army Corps of Engineers created a system of protected channels in the 1930s and joined them with the Dismal Swamp Canal. The cost of construction between St. Johns River, Florida, and Beaufort Inlet, North Carolina, was roughly $14.5

million. The waterway is seven feet deep and must be dredged periodically to maintain it.

Leaving the dock, on your left is the picnic area. Here you will find a long black bench.

Bench by the Road

This is the first memorial of its kind to be placed across the country at sites that were significant to the history of slavery. The idea came from novelist Toni Morrison, who was here at the dedication of the bench in the summer of 2008. Two decades before, she had expressed a need for memorials of any kind to the African slave trade. "There's no three hundred foot tower," she said, "no small bench by the road" where people could contemplate the history of slavery. The Toni Morrison Society, a nonprofit organization, took up the cause, which led to the placing of this first bench.

As you sit here, take a look at a few statistics that put this time in our nation's history into perspective. The African slave trade took place from 1500 to 1870. During that time, more than ten million Africans were taken captive from their homes and brought across the Atlantic to North and South America and the Caribbean.

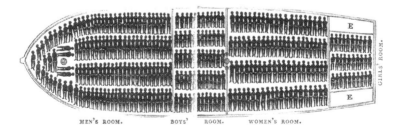

An illustration showing how to get the most slaves onto the ship during the Middle Passage. *Courtesy of the Library of Congress.*

85

Roughly one-third of white households in the lower South owned at least one slave in 1860. In the Sea Islands of South Carolina and Georgia, aspects of the Gullah culture (diet, language and folklore) were also adopted by whites. The menus of Lowcountry restaurants frequently include foods that have been a part of the African diet for centuries. Lastly, slaves were an integral part of the history of Fort Moultrie. They built much of it from the ground up and created the bricks you see in the outer walls. They were here as the fort was being bombarded during both the Revolutionary War and the Civil War. And among the twelve killed on June 28, 1776, was an officer's slave.

Walk past the dock again toward the iron fence and flagpole.

William Moultrie Burial Site

This is the burial site of General William Moultrie (1730—1805). An experienced fighter, Moultrie was a veteran of the French and Indian War. At the outbreak of the Revolutionary War, he was the man responsible for the construction of this fort and the defense of it. The state flag was taken from a flag he designed to fly over the fort. His had a blue background and a crescent moon with the word "Liberty" in white letters. In 1776, the First South Carolina Regiment wore crescent shapes on their caps like the one on this flag. The palmetto tree was used in the construction of the fort, and its solid spongy texture resisted splintering and saved lives during bombardment.

When the British took Charleston in 1780, Moultrie was among those imprisoned and later exchanged. After the war, Moultrie was elected governor of South Carolina in 1785. When he died, Moultrie was originally buried on his family's plantation, Windsor Hill. When Fort Moultrie was converted to a museum under the National Park Service, his remains were moved here in 1978.

Fort Moultrie

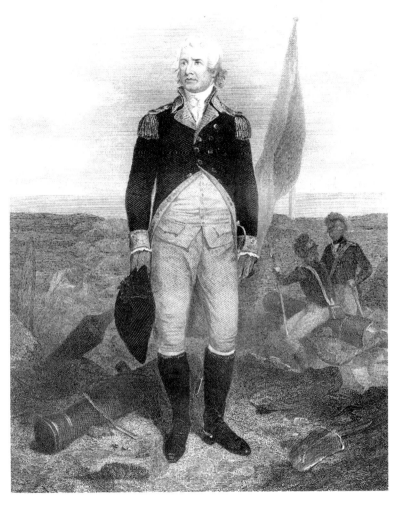

An engraving of Colonel William Moultrie to commemorate the battle of Sullivan's Island.

Now head down toward the visitors' center. It was built on the location of the former Fort Moultrie Hospital, Dispensary and Dead House. On the right of the visitors' center is a stairwell leading to a rooftop observation deck. This is the best view (and the best breeze) you will find on the island. It's also a good place to

talk about how Fort Moultrie got its name and why we celebrate Carolina Day—June 28, 1776.

Of course, you've heard about the Declaration of Independence, which was signed by the Continental Congress in Philadelphia on July 4, 1776. But the fighting began way before that. In fact, the Americans threw down the gauntlet in 1774 by forming such a congress and refusing to trade with Great Britain. The battle at Lexington and Concord followed in the spring of 1775, and there was no turning back. South Carolina formed a Council of Safety to put together regiments, confiscate gunpowder from British supplies and build forts.

Sullivan's Island was an obvious choice for a new fort. It had a great view of the harbor and had already been used as a signal station and pilothouse. Colonel William Moultrie was placed in charge of the construction and defense of the fort. Being a plantation owner, he used people who were already at his disposal—slaves—to do the work. While Colonel William Moultrie was hastily building the fort of palmetto logs and sand, he was also left with a group of runaway slaves who had come to the island to join Lord William Campbell. The royal governor made promises of freedom but left them behind on the island when the British sailed in search of provisions.

Colonel Richard Richardson wrote for help in January 1776: "We have all reason which the nature of the case will admit of, for expecting a visit from those ships, when wind and weather permits. We are going on preparing for defense; five capital guns are mounted at Sullivan's Island; we intend to add more, but we are really in want of the assistance of good men from the country, such especially as are expert in handling the rifle." It's very likely that the backcountry Loyalists that Richardson sent with Colonel Thomson to work on his battery at Breach Inlet also worked here before being released.

In early June 1776, Major General Charles Lee and Brigadier General Howe toured the fortification. Lee was skeptical, at best, and didn't think the little fort would hold. He was concerned that Sullivan's Island would be a slaughter pen, since there was no easy way to retreat. President Rutledge, however, insisted that Moultrie should stay where he was. Moultrie, not planning on needing a retreat, was

confident that the palmetto fort would hold.

Lee was still concerned. Rather than risk having so much ammunition confiscated by the British, Lee had some of it removed from the island. He also transferred some of Moultrie's men and ordered a pontoon bridge to be built across the cove from Mount Pleasant. So Colonel Moultrie, with one hand tied behind his back and little vote of confidence from his superior officer, continued his work while waiting for the arrival of nine British ships of war. Their total firepower amounted to roughly 260 cannons.

A 1776 British cartoon of stubborn "Miss Carolina Sullivan." *Courtesy of the Library of Congress.*

Early in the morning on June 28, Moultrie saw the ships approach from the direction of Long Island. As soon as they were in front of the unfinished fort and within firing range, they dropped anchor. It was 10:00 a.m. when the British ships began firing, and they didn't stop until after 9:00 p.m. when it was dark. All day, the Patriots fired back, slowly and cautiously since they had a limited supply of gunpowder. Nevertheless, it was said that they "swept the British decks with frightful carnage." Commodore Sir Peter Parker aboard the *Bristol* lost an arm in the battle.

At one point during the bombardment, the flagstaff was hit and fell outside the fort. Sergeant William Jasper ran across the outside of the fort and retrieved it. Captain Horry passed him a sponge-staff (used to plunge powder into a cannon), and Jasper used it to raise the flag again.

In the end, the ships slipped their cables and sailed out of reach of the guns. As an interesting side note, Commodore Parker came back to fight in the War of 1812. He was killed in action near Baltimore, Maryland.

A Tour of Historic Sullivan's Island

During the British occupation, the fort was named Fort Arbuthnot for the commander of the British fleet, Vice-admiral Mariot Arbuthnot, who contributed to its capture in 1780. It was called Fort Moultrie as early as 1794, though Moultrie himself sometimes modestly referred to it simply as the Fort on Sullivan's Island. He said it was a "convenient and healthy spot" for quartering federal troops and set about making improvements to it that year with the help of Daniel Desaussure. A total of $1,290 was spent on "negro labourers," their rations and their overseers' wages. No doubt these were slaves rented from plantation owners.

Go inside and pay to see the fort. It's a very small fee and well worth it. There is a brief movie on the history of the fort that is shown in a comfortable little theatre next to the gift shop.

Points of Interest Inside

While you're walking around inside the museum, you'll see a replica of Sergeant Jasper's makeshift flagpole. There are also images of freedman Jacob Stroyer and General P.G.T. Beauregard. There is also a historic video of soldiers operating a ten-inch disappearing gun.

If you're a fan of the movie *Jaws*, you no doubt remember the scene on the *Orca* when Captain Quint told the story of being on the USS *Indianapolis* when it sank in 1945 and the gruesome details of how most of his shipmates were taken by sharks. The event described in the movie really happened, and you will find a copy here of a newspaper article on the sinking of the ship and the fact that it went down in less than fifteen minutes.

The museum also has an interesting new slavery exhibit describing how slaves were captured and the long Middle Passage between Africa and North America. Try to read the Gullah Bible on display.

Outside is a crosswalk that will lead you to the Sally port of the fort. The centuries-old term "Sally port" referred to an opening in a fortress where soldiers could rush out and surprise the enemy. In later years, it was the name given to the main entrance of a fort. This

Fort Moultrie

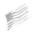

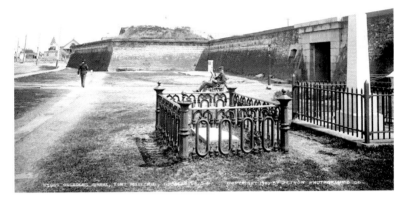

A view in 1900 of the Sally port and monuments at Fort Moultrie. *Courtesy of the Library of Congress.*

entrance was once flanked by wooden buildings. It was more ornate during the first half of the nineteenth century. The antebellum façade had Greek columns and a pediment.

The two monuments just to the right of the Sally port were officially declared National Monuments by an act of Congress in 1915. They are memorials to Seminole leader Osceola and to the crew of the Civil War ironclad monitor *Patapsco*.

Osceola

So how did a Seminole from Florida end up being buried here? Osceola (1804–1838) was born of a Creek woman and a white man by the name of Powell. For this reason, Osceola was sometimes

referred to as Powell in contemporary accounts. Though he was not a chief, Osceola was a leader in his own right and was at the head of a group of warriors in the Seminole War (1832–38). In October 1837, he and his men were invited to a meeting with General Hernandez under a flag of truce. Andrew Welch, a friend of Osceola's nephew, wrote in 1841 that the Seminoles placed their rifles against a tree as they were asked to do. "As soon as the white troops showed themselves, they were immediately seized upon, leaving the Indians defenseless." Osceola, eighty of his men, his wife, his young son and two other women were taken prisoners to a fort in St. Augustine and then transported here to prevent them from being rescued.

Osceola wasn't the only important Seminole imprisoned here at the time. The public, however, was particularly fascinated with him. He may have been more of a curiosity than an honored guest. He spoke no English, yet artist George Catlin (famous for his portraits of Native Americans) managed to interview him just days before he died. His impression of Osceola was that he was a man of contrasts—an outsider with a white father who became a war leader of the Seminoles, an effeminate-looking man who was brave and stern and a man "withering under a broken spirit endeavoring to raise a smirk and a smile to meet the gazing world flocking to see him." The *Charleston Mercury* commented that "from a vagabond child, he became the master spirit of a long and desperate war."

While imprisoned, Osceola became weak and developed a fever and an abscess of the tonsils. "Sad and tired of the world," the warrior died in January 1838. But the story of Osceola doesn't end there. In fact, it has a strange twist to it. Adding insult to injury, Osceola was buried headless and without his personal possessions. "Who would do this to him?" you might ask. Well, here's another strange twist. The doctor who attended him was Dr. Frederick Weedon, an army physician who accompanied the Seminole prisoners from St. Augustine. He was the brother-in-law of General Wiley Thompson, who was killed by Osceola in a skirmish in 1835. Weedon was justifiably nervous that Charlestonians would blame him for the Seminole's death, so he gave a full account to the *Courier* of Osceola's illness and his family's refusal of treatment. The story was corroborated by Dr. B.B. Strobel of the Medical College (MUSC).

Fort Moultrie

This sketch of Osceola was made just two days before he died. *Courtesy of the Library of Congress.*

Weedon's own descendants say that he was the one who removed Osceola's head and took it home with him. Here is where the story gets even more bizarre. According to his children, Weedon kept the head in his home and used it as a tool for discipline. If one of

the children was naughty, the child had to spend a night with the head perched on his bedpost. Eventually, Osceola's head made its way to the Surgical and Pathological Museum in New York, which was destroyed by fire in 1866.

There was evidence in 1966 that grave robbers made an attempt at Osceola's grave and rumors that his body had been stolen and taken back to Florida. So the National Park Service exhumed the grave. E.P. Chiola was there the day they dug it up. In spite of the fact that Osceola was said to have been buried with his bullet pouch, knives and silver spurs, there was nothing in his grave but bones—no skull and no artifacts. It also looked as though the casket had been tilted to one side when it was placed in the grave, since the bones were lying on one side. The official Seminole stance on the matter is that only when the head is returned will the body be requested to return to Florida. The closest thing to that is his death mask, a cast made of his head the day after he died. Osceola's death mask is on display at the New York Historical Society.

In death, Osceola became even more famous than when he was alive. Though he died of an illness, doing so in a federal prison made him somewhat of a martyr. This marble monument calling him a patriot was erected in his honor not long after his death. In the late 1800s, songs were written about him, books were published on him and steamboats were named after him. Even small towns across the country took his name. And for those suffering from chronic rheumatism, gout or pain of any kind, there was the patented Clement's Genuine Osceola Indian Liniment, made in Philadelphia.

Patapsco Monument

Osceola isn't buried here alone. Next to him are five crew members of the ironclad monitor USS *Patapsco*. It was built in Wilmington, Delaware, in 1862 and was the subject of curiosity and admiration

Fort Moultrie

as it cruised into the navy yard at Philadelphia just after Christmas to receive its stores. Rising a mere eighteen inches above the surface of the water, only its smokestack and revolving gun turret could give it away at a distance. Philadelphians nicknamed it the "cheese box" and flocked to see it the week it was there.

The ship was to be the latest addition to the South Atlantic Blockading Squadron bottling the harbors of the Confederacy. From bow to stern, it was two hundred feet long and protected by one-inch-thick iron plates. Unlike on the *Passaic* and *Weehawken*, the new rifled cannon (capable of firing a ball almost six miles) had been added to its armament. The other, a fifteen-inch Dahlgren gun, weighed forty-five thousand pounds and required thirty-five pounds of gunpowder per shot. Each gun needed eight men to operate. Commander Pierce Crosby was at the helm when the ship pulled out of the harbor with sixty crew men and headed south.

In April 1863, Northern newspapers declared that Charleston had to be taken before the heat of the summer set in and the spring campaign closed in disgrace. The *Patapsco* made its way with the monitor fleet toward Charleston Harbor. They arrived in June and combined forces with the Union army to attack Battery Wagner on Morris Island and Fort Sumter. The captain later described in his report the "hissing, shrieking missiles…which seemed alive with fire."

In the middle of the night on January 15, 1865, while covering picket launches between Fort Sumter and Fort Moultrie, the *Patapsco*

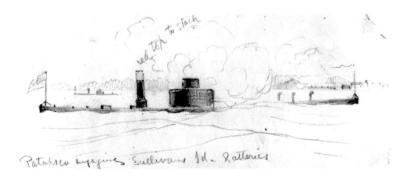

This sketch of the *Patapsco* was made by an unknown sailor during the Civil War. *Courtesy of the Library of Congress.*

struck a sunken torpedo. Because of its low profile, it submerged in less than a minute, becoming the third ironclad monitor to lie at the bottom of Charleston Harbor. The other two were the *Keokuk* and the *Weehawken*.

At the helm the night the *Patapsco* sank was Lieutenant Commander S.P. Quackenbush. He and forty-two others were on deck and survived. The other sixty-two, including the ship's surgeon and his assistant, were below and perished with the ship. In 1870, a contract was awarded by the U.S. Treasury Department to the Monitor Wrecking Company to raise the sunken monitors and salvage the wreckage. In 1873, French engineer Professor Maillefort displayed artifacts from the *Patapsco* as they were brought up and taken to a Charleston warehouse. Among them were neckties, watches, medicine chests and surgical instruments. A barge built specifically for Maillefort by the Samuel J. Pregnall and Brother Shipyard (see 2662 Jasper Boulevard) hauled more than four hundred tons from the wreck, including iron plates riddled with marks from Confederate shot and shell. The scrap, along with tons from other wrecks in the harbor, was taken to Richmond and converted to rails for train tracks. The bones of crew men found in different sunken ships during the operation were buried in Magnolia Cemetery. Five crew members of the *Patapsco* are said to be buried beneath this obelisk.

Go now through the Sally port and into the fort. Follow the arrows that lead you on a tour of the area. If you have your cellphone, you can call the posted numbers and listen to a brief narrative. One interesting structure in the fort is the traverse. It is made of solid brick to protect the main powder magazine.

In the U.S. census of 1880, Seth Leslie was listed as the "fort keeper" with no other soldiers listed as being stationed here. Six years later, however, a dramatic change was on the way. That year the Board on Fortifications or Other Defenses submitted its report to Secretary of War William C. Endicott outlining where America's coastal defenses needed to be increased. Sullivan's Island was on that list. Both

Fort Moultrie

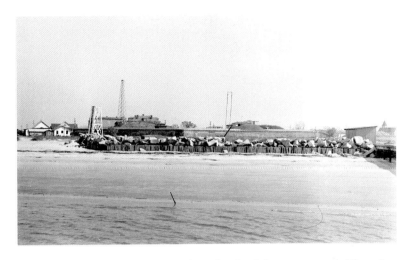

This is a 1935 view of Fort Moultrie from the wharf that once extended from the beach. *Courtesy of the Library of Congress.*

Battery Bingham (1898) and Battery McCorkle (1899) were added to the fort. They were constructed here to protect the minefield from being disarmed under cover of darkness, as the *Patapsco* was trying to do when it sank during the Civil War.

By 1910, there were roughly five hundred men stationed at Fort Moultrie. Several of them, particularly the officers, were married and had their families with them.

Famous People Who Were Here

President George Washington was greeted with fanfare when he visited Charleston in 1791. Part of his itinerary was to see Fort Moultrie, made famous during the Revolutionary War. He toured what was left of it on May 5 and commented in his diary only that it was in ruins and "quite fallen."

Edgar Allan Poe (1809–1849), in an effort to escape creditors and gambling debts, enlisted in the army as a private in May

A Tour of Historic Sullivan's Island

A portrait of Edgar Allan Poe as a young man. *Courtesy of the Library of Congress.*

1828 under the assumed name Edgar A. Perry. He was sent to Fort Moultrie the same year but was only here for a few months. It's widely accepted that he used Sullivan's Island as the setting for "The Gold-Bug," published in 1843. He also published several poems after he left in 1829, any one of which could have been written while he was here.

Fort Moultrie

General Winfield Scott was sent here in secret by President Jackson to increase the garrison at the fort in the 1840s. Jackson was concerned about the talk of nullification in South Carolina.

For decades after the Civil War, General William Tecumseh Sherman was the most hated man among whites living south of the Mason-Dixon line. His "march to the sea" in 1864 put the final nail in the coffin of the Confederacy as his regiments targeted railroads, warehouses and other civilian targets. Before the war, however, he made quite a few friends in the short time that he was stationed here at Fort Moultrie. Dr. Paul Pritchard, a Charlestonian who knew Sherman as a cadet at West Point, said that he was "a good, genial boy, with no characteristic at that time in evidence of the questionable glory he was to achieve in his desolating march through Georgia to the sea."

Sherman was a young lieutenant in the small garrison with a lot of time between his duties to pause and reflect. He liked it here. On June 9, 1845, he wrote to his sweetheart back home in Ohio:

> *I am now officer of the guard. All of my comrades are away at a small party at the other end of the island, whilst I alone sit here in dead silence, listening to the echo of the sentinel's monotonous tread as he walks his post in the archway that pierces our battlements… Would that for a few short hours you could enjoy it, sitting on our piazza by the faint light of the new moon, listening to the rustling surf of the sea, and cooled by the fresh breeze that comes over the ocean. It is truly a lovely night when one may sit for hours and enjoy undisturbed that gentle quiet and repose that resembles a life of dreams rather than actual existence in the rascally world.*

The fort was peaceful then, and the view inspired him. In 1842, he decided to take up painting. He wrote,

> *I went to the city and laid in a full set of artist's equipments, prepared my studio, and without any instructions whatever have finished a couple* [of] *landscapes and faces which they tell me are very good. I have great love for painting and find that sometimes I am so fascinated that it amounts to pain to lay down the brush,*

A photograph of General William Tecumseh Sherman. *Courtesy of the Library of Congress.*

> *placing me in doubt whether I had better stop now before it swallows all attention, to the neglect of my duties, and discard it altogether, or keep on.*

While stationed at the fort, Sherman heard talk of secession but didn't believe it would ever actually happen. Because he did not think of Fort Moultrie as impenetrable prior to 1861, Sherman thought that South Carolina would be the first to fall during the war.

Fort Moultrie

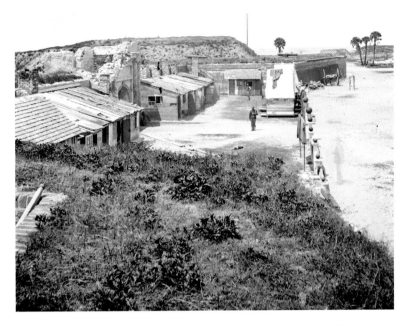

A Civil War view of the Sally port of Fort Moultrie in the direction of James Island. *Courtesy of the Library of Congress.*

Abner Doubleday (1819–1893) was an author and is credited with the invention of baseball. At the beginning of the Civil War, he was stationed here when his superior, Major Robert Anderson, decided to abandon the fort to the Confederates and head to Fort Sumter.

In 1862, General Robert E. Lee spent four months in Charleston and Savannah preparing the defenses of the two cities. Slaves were used to shore up the damage to the fortifications. General Beauregard complained of the deficiency of labor since the slaves were contracted from the owners for only thirty days at a time.

Just outside the walls of the fort is another battery.

Battery Jasper
(Site of Battery Beauregard)

Battery Beauregard was one of the most active Confederate batteries during the Civil War. It was constructed near here of earth and logs and armed with one eight-inch Columbiad and two rifled thirty-two-pounders. Two companies of Regulars were stationed here under the command of Captain Julius A. Sitgreaves. Rear Admiral William Rogers Taylor, USN, was senior officer of the South Atlantic Blockade Squadron in 1863. Of that time he wrote, "Firing along the line was so common an occurrence that no apprehension was excited by the guns."

Battery Jasper was completed as part of the Endicott System of Coastal Defense in 1898. It was named for Sergeant Jasper, who fought in the Revolutionary War. During the Cuban Missile Crisis in October 1962, residents set up the vacant battery as a makeshift nuclear fallout shelter. This one was chosen over the other batteries because it had a cistern.

If you walk down to the beach, you can get a view of some of the older homes across from Fort Sumter. There is also a line of rocks called the grillage.

The Grillage or Bowman's Jetty

You may wonder why the fort was built so far back from the water. It wasn't, actually. But over time the land accreted here like on most of the island. This is thanks, in part, to the grillage, or the line of rocks leading into the water in front of Fort Moultrie. It was designed by Captain Alexander Bowman of the Army Corps of Engineers in the 1840s. Until that time, the island had been suffering from erosion. In October 1802, the *Salem Register* reported a phenomena on the beach about two hundred yards from the fort:

Fort Moultrie

A variety of fissures appeared upon the surface of the beach; immediately it began to fall in with a dreadful noise, and continued to fall, at short intervals, until half after one o'clock p.m. At which time, a gentleman took a small boat in order to sound the depth, which inside the circle of half-moon, (which was the form it assumed, and which is at present two hundred and forty feet in circumference) was betwixt two and three fathom deep. The land seemed to fall in large pieces, some of them, I suppose, about five hundred weight, leaving the body of the beach altogether perpendicular.

This nine-foot-deep fissure was reason for concern.

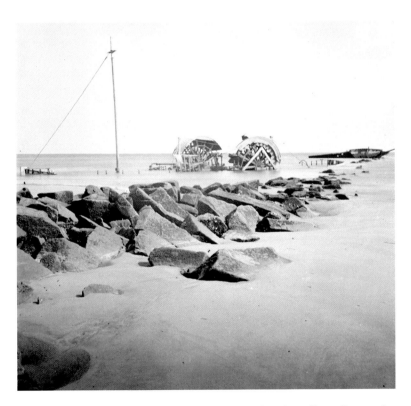

The wreckage of a blockade runner that ran aground on the grillage. *Courtesy of the Library of Congress.*

A reporter for the *Southern Patriot* noted in 1848 that

> *The erection of Fort Sumter has thrown the tide so strongly on the South side of this Island, (in which direction it had a tendency before) that the Government of the United States has been compelled to erect a sea wall from below the Fort to the north-western point of the Island. It is now nearly finished, and promises to be a protection to the whole of this portion of it, at the expense, however, of its fine broad beach, which is much circumscribed by this encroachment.*

Since Bowman added the rocks, the jetty has not only halted erosion but has also facilitated the addition (or accretion) of land here. During the Civil War, however, the grillage was both a benefit and a hindrance for Confederates. Blockade runners and ships of the Blockade Squadron ran aground on it. Among them was the blockade runner *Presto*, which ran aground in February 1864.

An effort was made by the federal government after the Civil War to raise many of the ships littering the bottom of the harbor. The *Georgia Weekly Telegraph* reported in 1870 that "store-ships [like the *Housatonic*], blockade-runners, torpedo boats, vessels of every known variety, fitted for war or peace, are found by the divers, strewn over the bottom…Probably there is not at present another place in the world where so many submerged wrecks are collected within so small a space."

Leading from the rocks to the water, you can see evidence of the dock that was once part of the Fort Moultrie wharf. Before the Cove Inlet Bridge was built, the only way for supplies and soldiers to get to the fort was by boat. The wharf was built before World War I and lasted for many years after. William B. Pozaro worked on the government boats. He started as an oiler and worked his way up to engineer of the *Sprigg-Carroll*. He was the son of an Italian immigrant and moved to Moultrieville with his mother, Margarett, and his younger brother Charles. His wife was Margaret (Maggie) S. McGuire Pozaro (1884–1983), the daughter of Irish immigrants. They had six children who, according to daughter Agatha Mueller Thomas, were all called "fiddlers" after

Fort Moultrie

A photo taken at Battery Bee after the Civil War. *Courtesy of the Library of Congress.*

the little brown crabs that scurry across the beach. Since her father worked on the boat, Agatha and her siblings were allowed to ride it into Charleston.

Just in front of the fort is the approximate site of the old South Range Light that stood here in the 1800s. It was square, was built on top of an old oil room, was painted red and had a white picket fence around it. In 1880, Andrew Anderson was the keeper of the lighthouse. It was removed sometime around World War I.

A Tour of Historic Sullivan's Island

If you walk down toward the point across from Charleston, you will be in the area of another Civil War battery.

Battery Bee

This was the location of a half-moon (semicircular) battery that was constructed in the 1780s. Lieutenant Colonel J.C. Simkins was in command of three companies of Confederate infantry here during the Civil War. The battery was armed with six Columbiad guns: five ten-inch and one eight-inch. Farther down toward the point was Battery Cove. After the war, these batteries were no longer needed, and houses were built where they once stood. Just like with the other island fortifications, the land was given over in peacetime to better use.

Our tour of Sullivan's Island ends on the beach where the island's history began. Here was the sentinel of the harbor, the haven for the sick, the playground for the rich. Through it all, the tides came and went just as they do today—ceaseless, indifferent to man, yet reassuring.

Sources

In researching this work, I combed through more books and documents than I can count. The best place to find local history is at the South Carolina Reading Room in the Charleston County Library on Calhoun Street. The helpful and knowledgeable staff can direct you to whatever information you're looking for, including online resources. It was there that I learned how to access all of the historic newspaper articles I used for this book.

You will find that a lot of the books I referenced are under the category of primary sources. In other words, many of them are firsthand accounts of events that took place on Sullivan's Island. It's important to get the story straight from the horse's mouth, so to speak, since misinformation in a later history book (a secondary source) may be repeated in others. The only problem is that sometimes primary sources wrote down their recollections of long-ago events from faded memory. I had to check and double-check my facts in those cases.

Following is a list of sources. I hope they will be helpful to you.

Sources

Adams, Herbert B., ed. *Johns Hopkins University Studies in Historical and Political Science*. Vol. 22. Baltimore, MD: Johns Hopkins Press, 1894.

Allen, Hervey, and Dubose Heyward. *Carolina Chansons: Legends of the Low Country*. Atlanta: MacMillan Company, 1922.

Anderson, Lars. *Paynes Prairie: The Great Savanna, a History and Guide*. Sarasota, FL: Pineapple Press, Inc., 2004.

Chestnutt, David R. *The Papers of Henry Laurens*. Vol. 2, *1776–1777*. Columbia: University of South Carolina Press, 1988.

Doubleday, Abner. *Reminiscences of Forts Sumter and Moultrie in 1860–61*. New York: Harper & Brothers, 1876.

Gadsden Cultural Center. *Images of America: Sullivan's Island*. Charleston, SC: Arcadia Publishing, 2004.

Gibbes, Robert W. *Documentary History of the American Revolution*. New York: D. Appleton & Co., 1857.

Gorgas, F.J.S., MD, DDS, and Richard Grady, MD, DDS, eds. *The American Journal of Dental Science*. Third Series 25, no. 9 (January 1892). Baltimore, MD: Snowden & Cowman.

Hays, Isaac, MD, ed. *The American Journal of the Medical Sciences* 32 (1856). Philadelphia: Blanchard & Lea.

Hicks, Brian, and Schuyler Kropf. *Raising the Hunley: The Remarkable History and Recovery of the Lost Confederate Submarine*. New York: Ballantine Books, 2002.

House of Representatives. *Army Appropriation Bill, 1918*. Washington, D.C.: Government Printing Office, 1917.

How, M.A. DeWolfe, ed. *Home Letters of General Sherman*. New York: Charles Scribner's Sons, 1909.

Irving, John B. *Local Events and Incidents at Home*. Charleston: A.E. Miller, 1850.

Johnson, Betty Lee. *As I Remember It, An Oral History of the East Cooper Area*. Charleston, SC: self-published, 1987.

———. *As I Remember It*. Vol. 2. Charleston, SC: self-published, 1989.

Johnson, Robert U. *Battles and Leaders of the Civil War*. Vol. 3. New York: Century Company, 1888.

Lawson, John D., ed. *American State Trials: A Collection of the Important and Interesting Criminal Trials which have taken place in the United States, from the beginning of our Government to the Present Day*. Vol. 4. St. Louis, MO: F.H. Thomas Law Book Co., 1915.

Lossing, Benson J. *The Pictorial Field-book of the Revolution: or, Illustrations, by Pen and Pencil, of the History, Biography, Scenery, Relics, and Traditions of the War of Independence.* New York: Harper & Brothers, 1852.

McCrady, Edward. *The History of South Carolina under the Proprietary Government, 1670–1719.* New York: Macmillan Company, 1901.

Miles, Suzannah Smith. *Island of History: Sullivan's Island from 1670–1860.* Charleston, SC: 2004.

———. *Writings of the Islands: Sullivan's Island and Isle of Palms.* Charleston, SC: The History Press, 2004.

Pendered, Norman C. *Stede Bonnet: Gentleman Pirate.* Manteo, NC: Times Printing Co., Inc., 1977.

Pinckney, Rev. Charles C., DD. *Life of General Thomas Pinckney.* New York: Houghton Mifflin & Co., 1895.

Prichard, Dr. Paul. "Reminiscences of an Octogenarian." *Alkahest Magazine* 7, July 1900. Atlanta: B.F. Johnson Publishing Company.

Ramsey, David. *Memoirs of the Life of Martha Laurens Ramsey.* Charleston, SC: Samuel Etheridge Jr., 1812.

Rice, Allen T., ed. *North American Review.* Vol. 143. New York: 1886.

Rosen, Robert. *Confederate Charleston: An Illustrated History of the City and the People.* Columbia: University of South Carolina Press, 1994.

Simms, William G. *Father Abbot; or the Home Tourist.* Charleston, SC: Miller & Browne, 1849.

Snowden, Yates. *History of South Carolina.* Vol. 5. New York: Lewis Publishing Company, 1920.

South Carolina Historical Society. *Collections of the South Carolina Historical Society.* Vol. 5. Charleston: South Carolina Historical Society, 1897.

South Carolina Institute. *The Premium List of the South Carolina Institute.* Charleston, SC: Walker, Evans & Cogswell, 1870.

Stroyer, Jacob. *My Life in the South.* Salem, MA: Newcomb & Gauss, 1898.

Trescott, Paul. "Modern Mound Dwellers." *Sandlapper Magazine,* August 1969. Columbia, SC: Sandlapper Press, Inc.

United States Naval War Records Office. *Official Records of the Union and Confederate Navies in the War of the Rebellion.* Washington, D.C.: Office of Naval Records and Library, 1903.

SOURCES

Welch, Andrew. *A Narrative of the Early Days and Remembrances of Osceola Nikkanochee, Prince of Econchatti*. London: Hatchard and Son, 1841.

WEBSITES

www.ancestry.com
www.archivesindex.sc.gov
www.cdsg.org
www.monolithic.com
www.nao.usace.army.mil/Technical%20Services
www.1918.pandemicflu.gov
www.oysterguide.com/new-discoveries/bluepoint
www.pearlstine.net/companyhistory
www.southernhistory.us/osceola

About the Author

Cindy Lee graduated from the College of Charleston with a bachelor's degree in history. Her research and writing focus primarily on local history and biography. She lives in the Charleston area with her husband and two children.

Visit us at
www.historypress.net